Art•Therapy

Disney PRINCESS

100 IMAGES TO INSPIRE
CREATIVITY AND RELAXATION

Disney
EDITIONS

For information address Disney Editions,
1101 Flower Street, Glendale, California 91201

Printed in China
FAC-032479

First United States English Edition, November 2015
1 3 5 7 9 10 8 6 4 2

ISBN 978-1-4847-5740-6

Some day my prince will come

The imaginations of children throughout the world for generations have been fired up by these classic stories and legends of popular literature and culture: "Snow White," by the Grimm brothers; "Sleeping Beauty," as told by Charles Perrault; "Aladdin and the Enchanted Lamp," who's hero is the famous character from *The One Thousand and One Nights*; "The Frog Princess," a traditional Russian fairy tale; and "Rapunzel," a popular German tale.

All these fairy tales and stories, as well as many others, have been brought to life by Disney filmmakers, over the years. Snow White and Cinderella, both victims of their stepmothers, escape or endure and wait for better times undaunted in two early Disney full-length animated films. Fifty years later, a new generation takes on the roles (though not all have parents who purposely intend to harm them): Ariel disobeys her father and takes "destiny" into her own hands; Jasmine slips away from her golden prison; Pocahontas and Mulan take a stand at great risk to defend their people. Ten more years pass in Disney filmdom, and then Tiana appears, motivated simply by the desire to achieve her goal through hard work. Rapunzel follows, breaking out of her tower, while Merida, in *Brave*, refuses outright the marriage her mother attempts to impose upon her.

These masterpieces of film animation not only reveal a clear evolution of society, but prove that even today their heroines still ignite the imagination of young and old viewers alike. Young girls dream of becoming princesses, and—even when older—retain a part of those feelings, which allow one to still dream. Who has not been moved by the sweet melodies hummed by these heroines, or by the clumsy—or sometimes very crafty little animals— that accompany them, or by the wonderful ball gowns and magical castles one comes across in these stories?

In this collection of motifs, you will find all the accessories of the Disney princesses: glass shoes, spinning wheels, coaches, shells, roses, lanterns, and tiaras. Use your brightest colors to enliven the elegant outfits of these characters and make the mandalas and other compositions of this work stand out.

Relax, venture back in time, and enjoy the pleasure of creation.

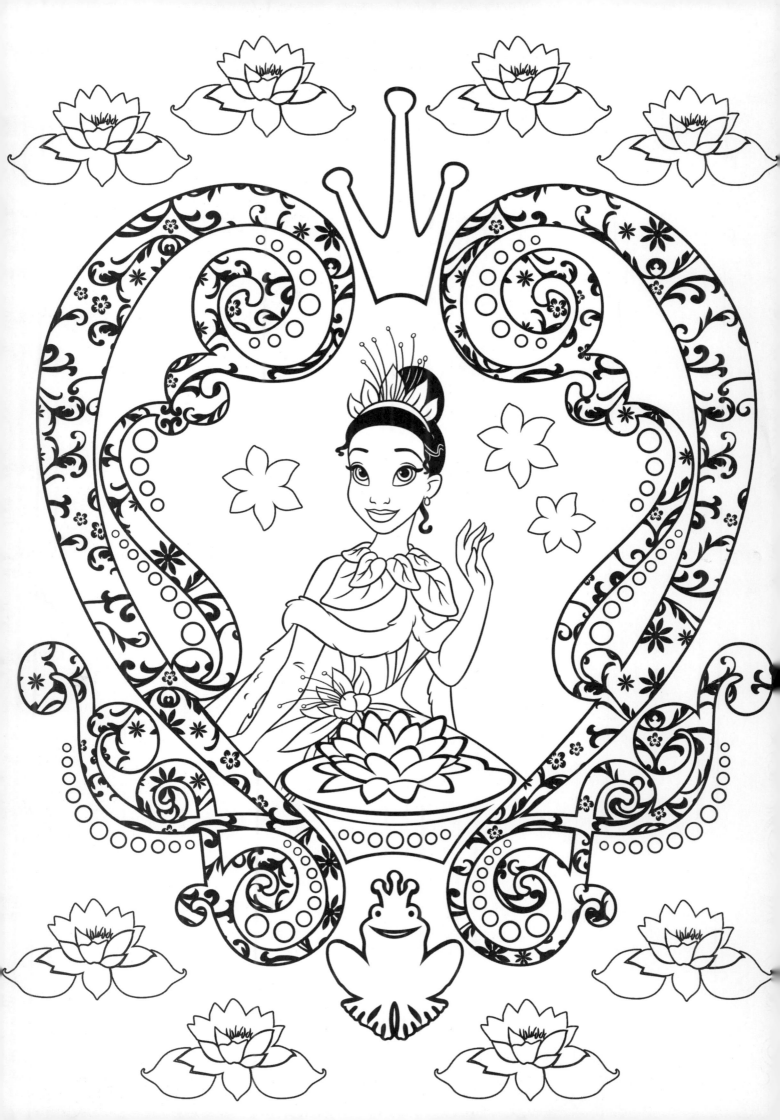

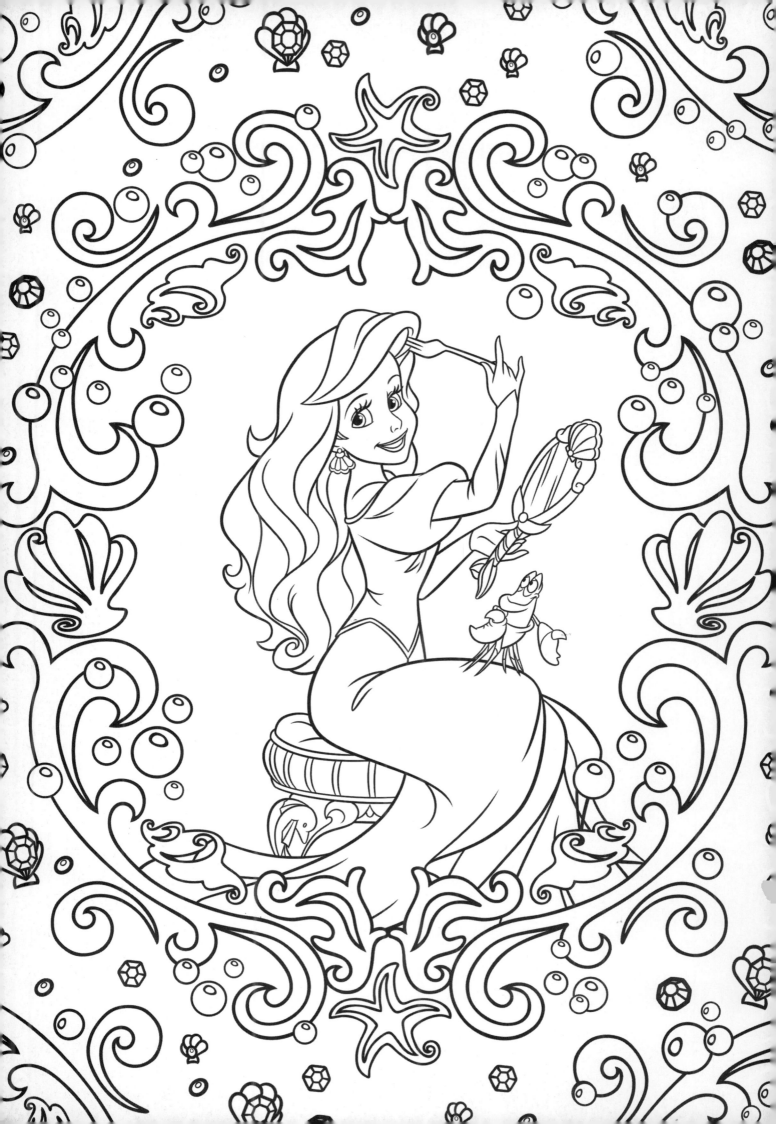

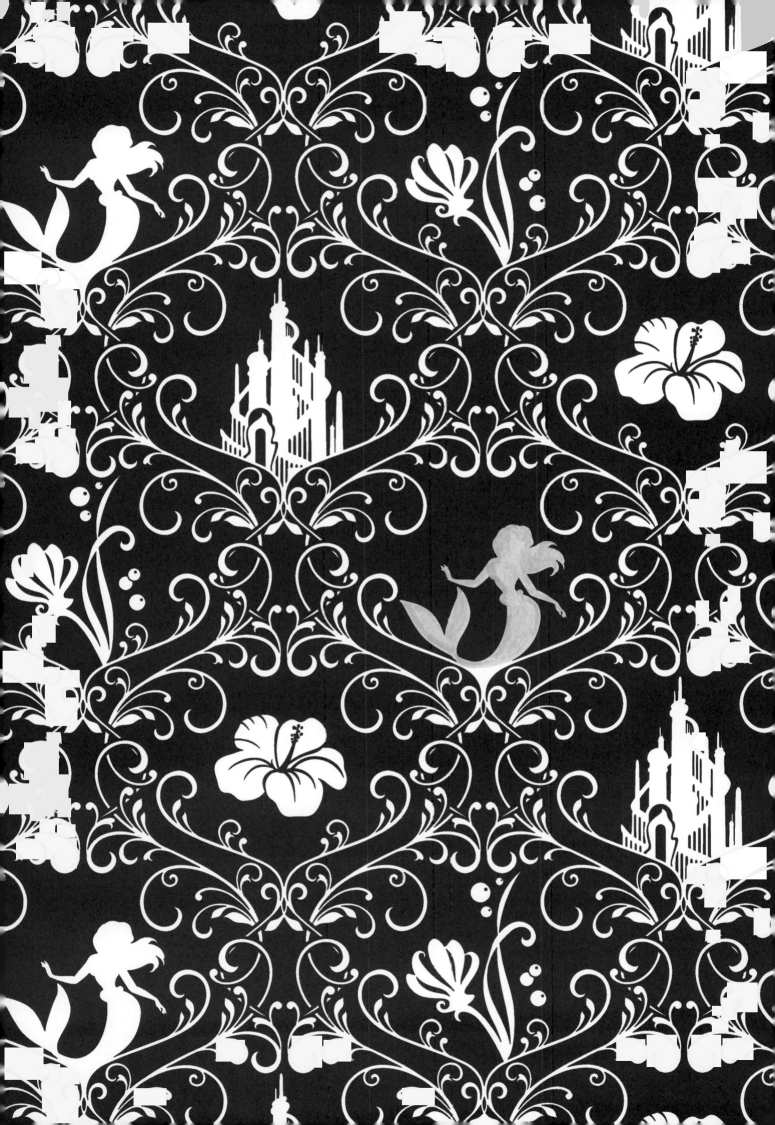

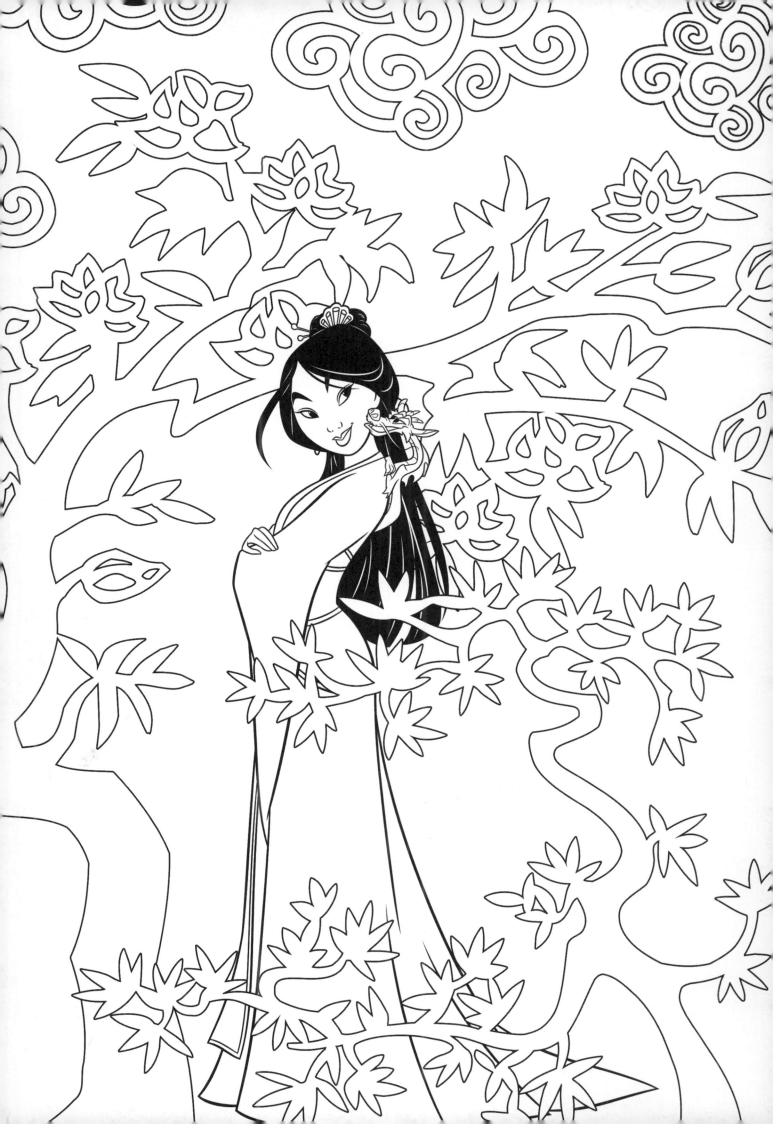

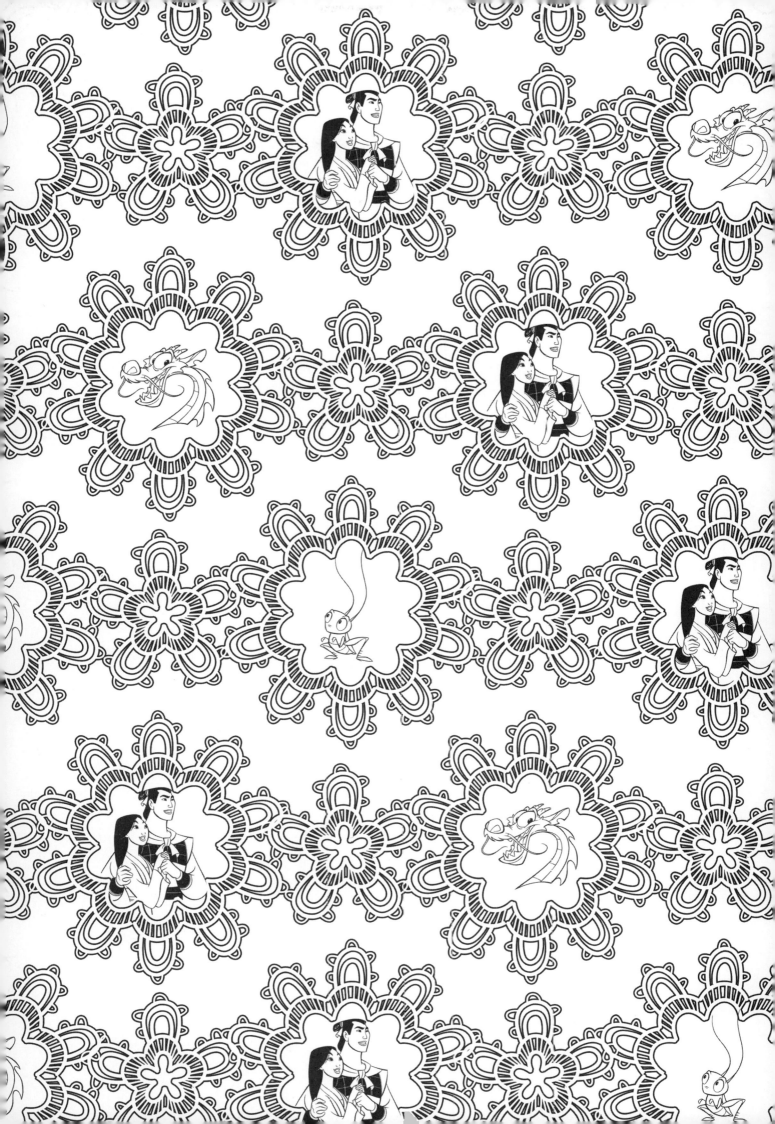

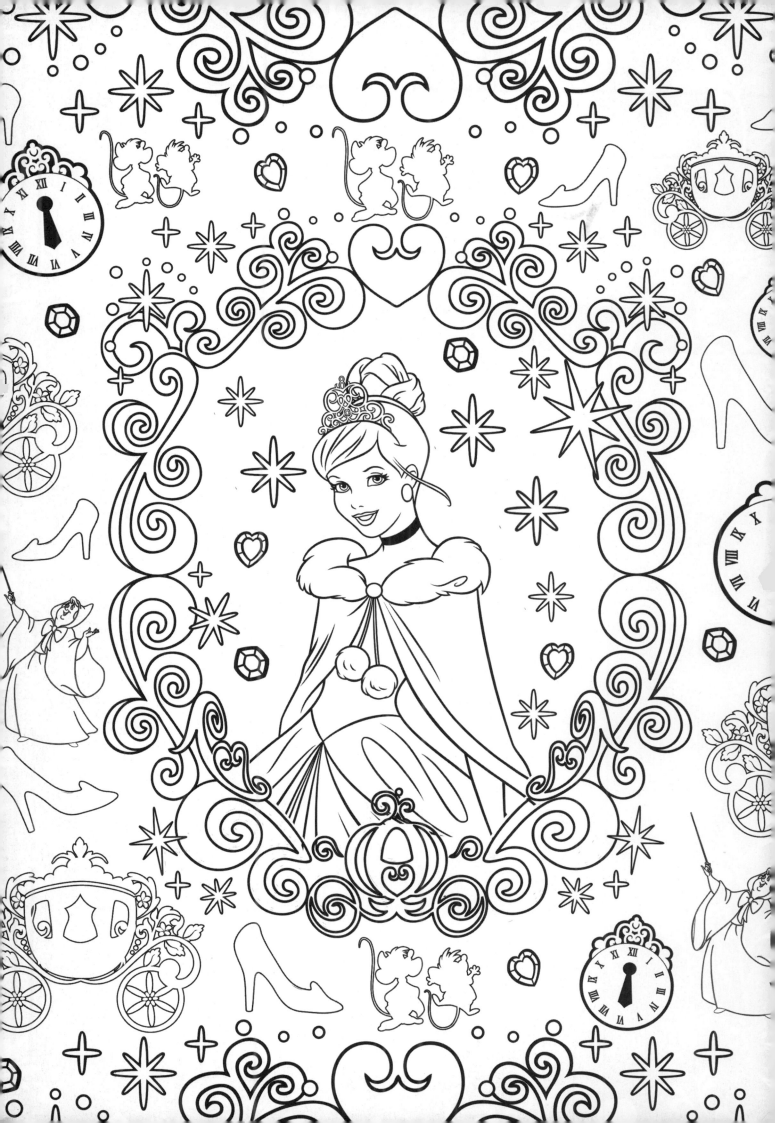

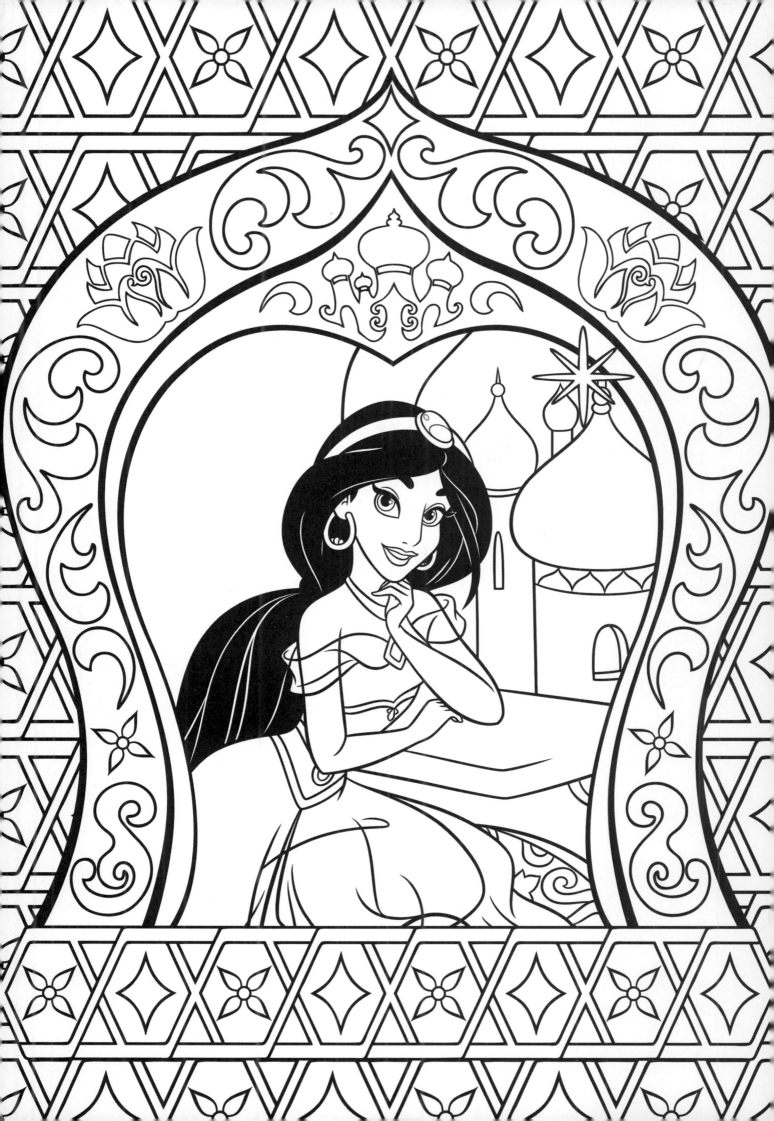

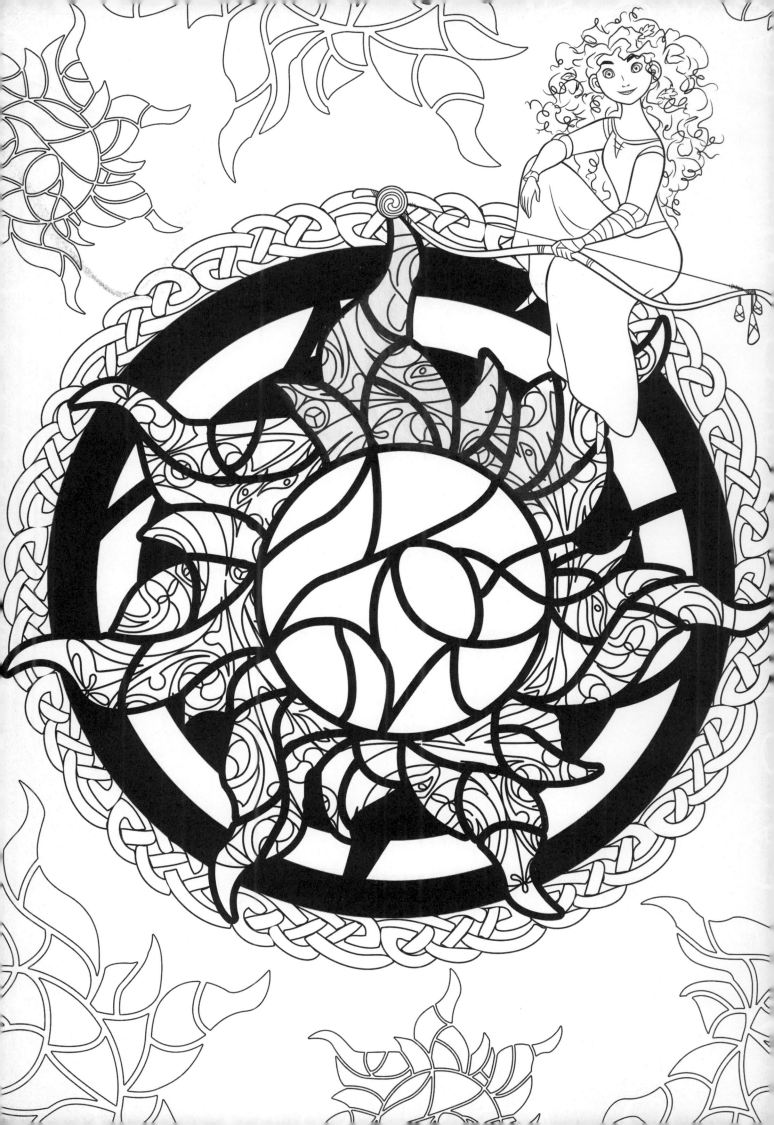

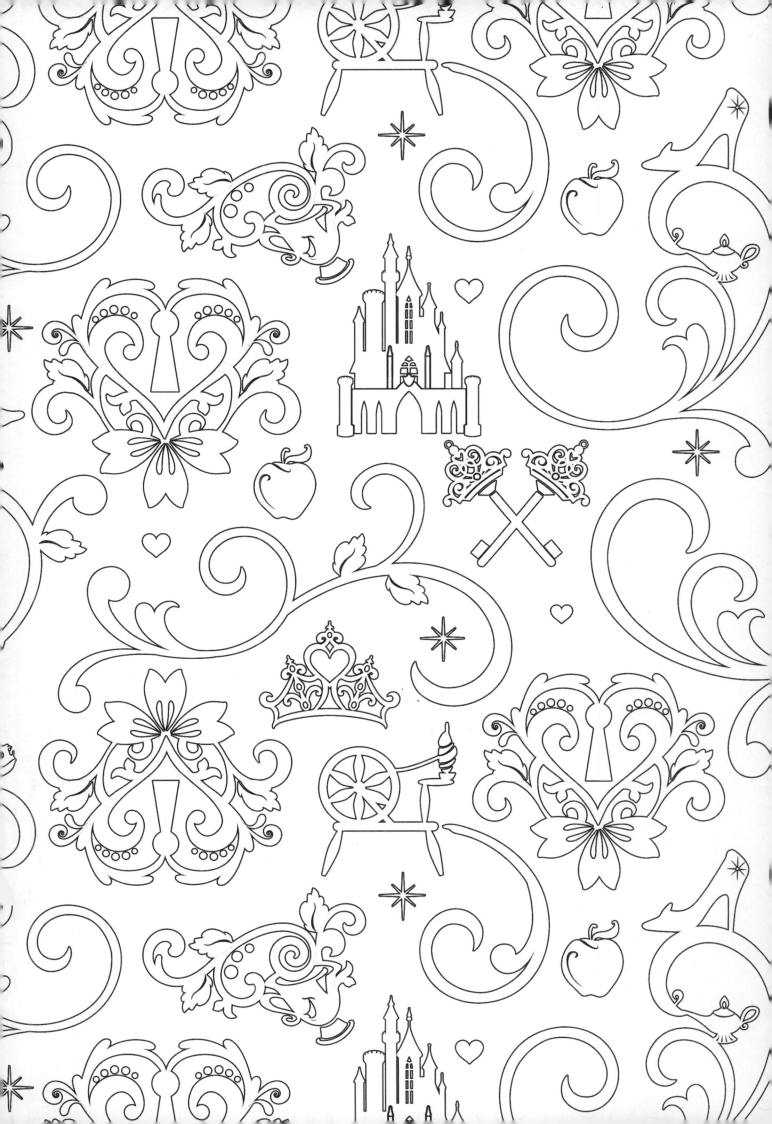

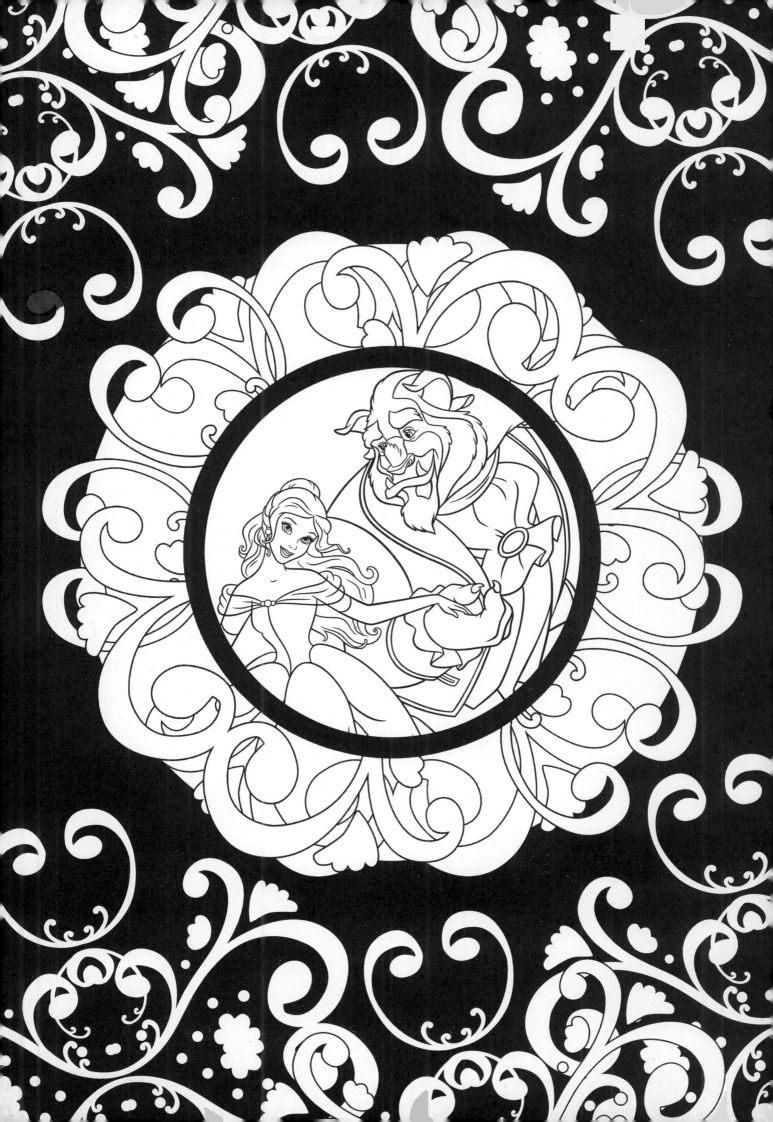

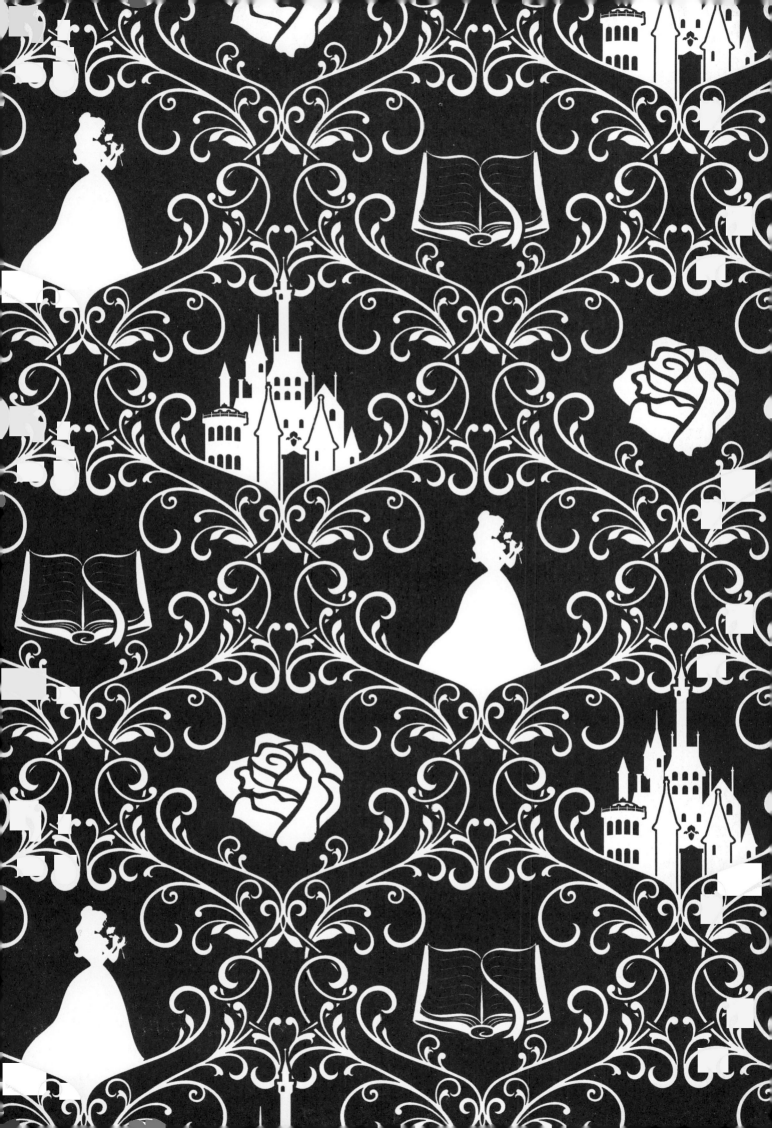

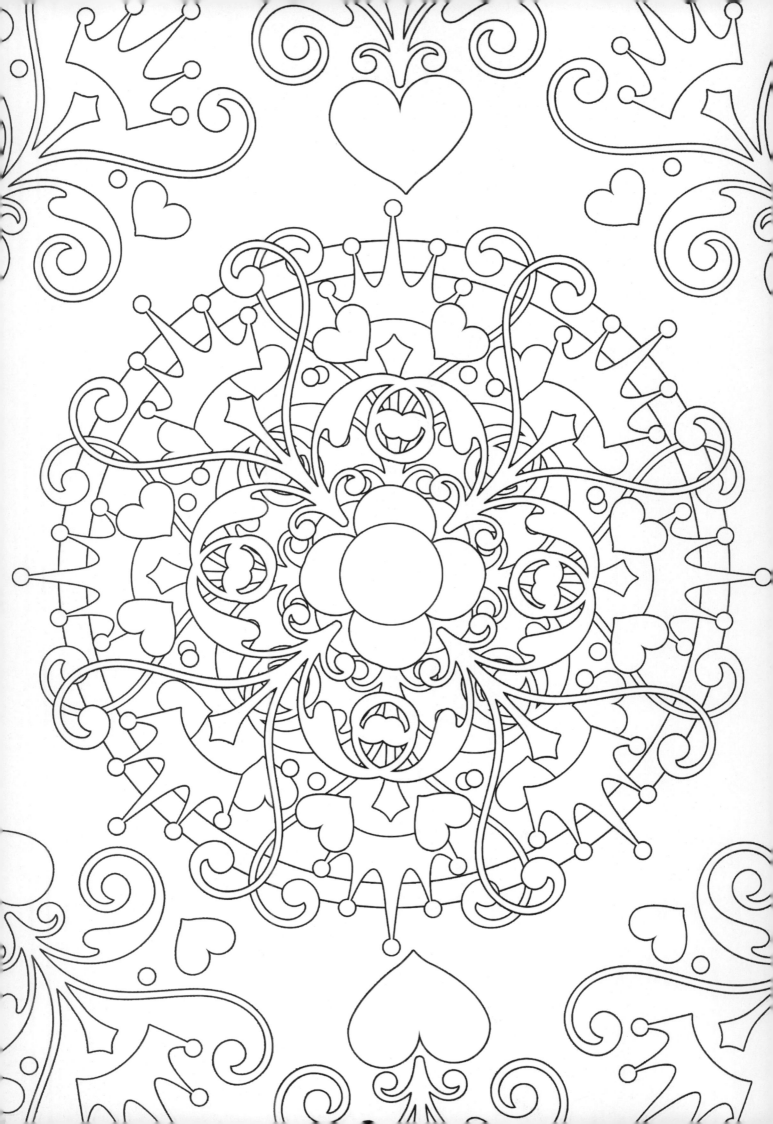

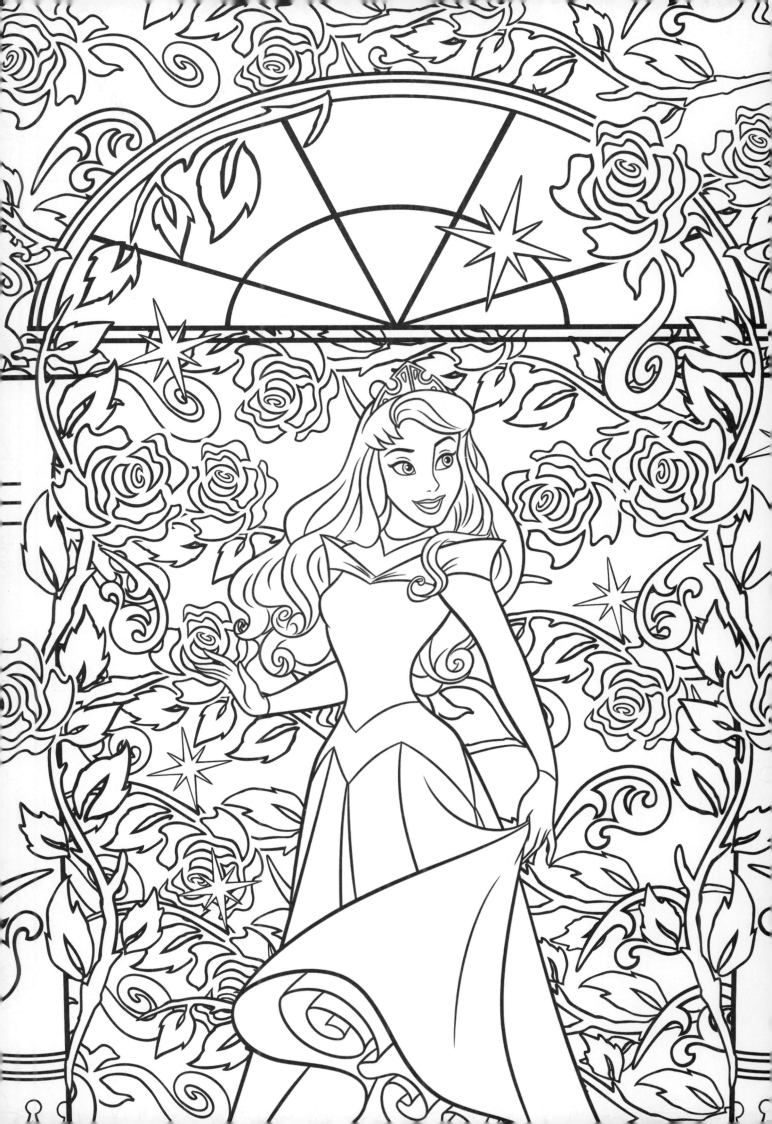

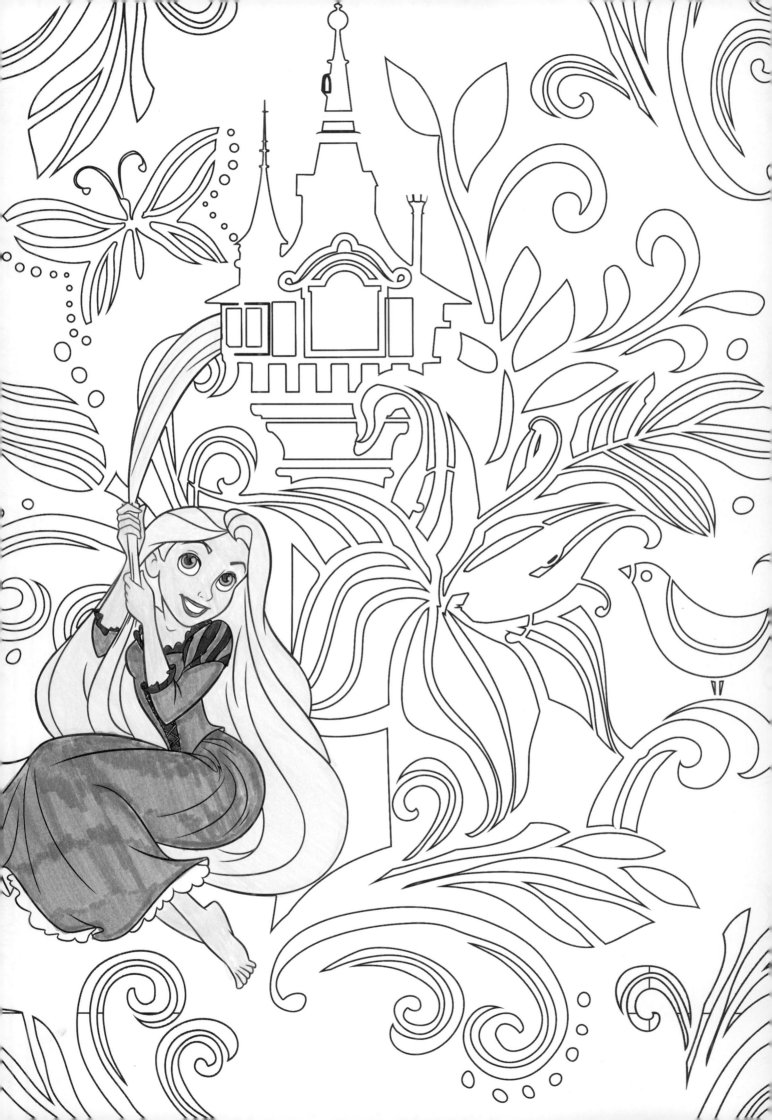

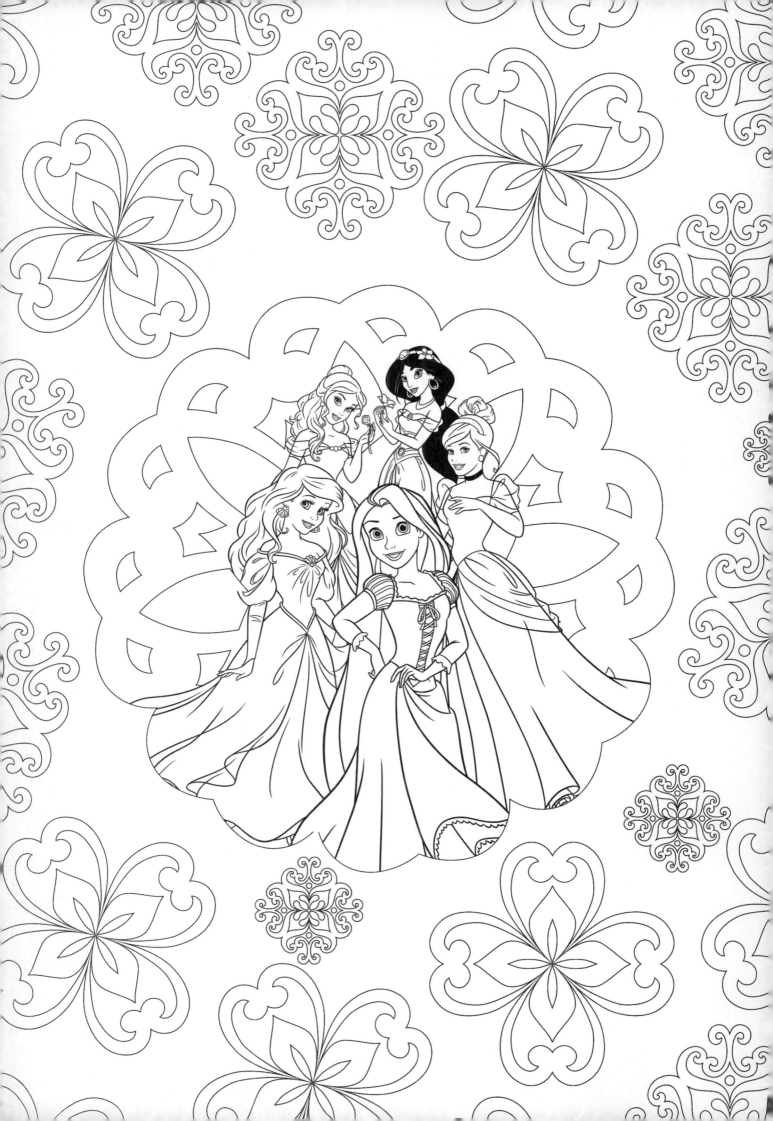

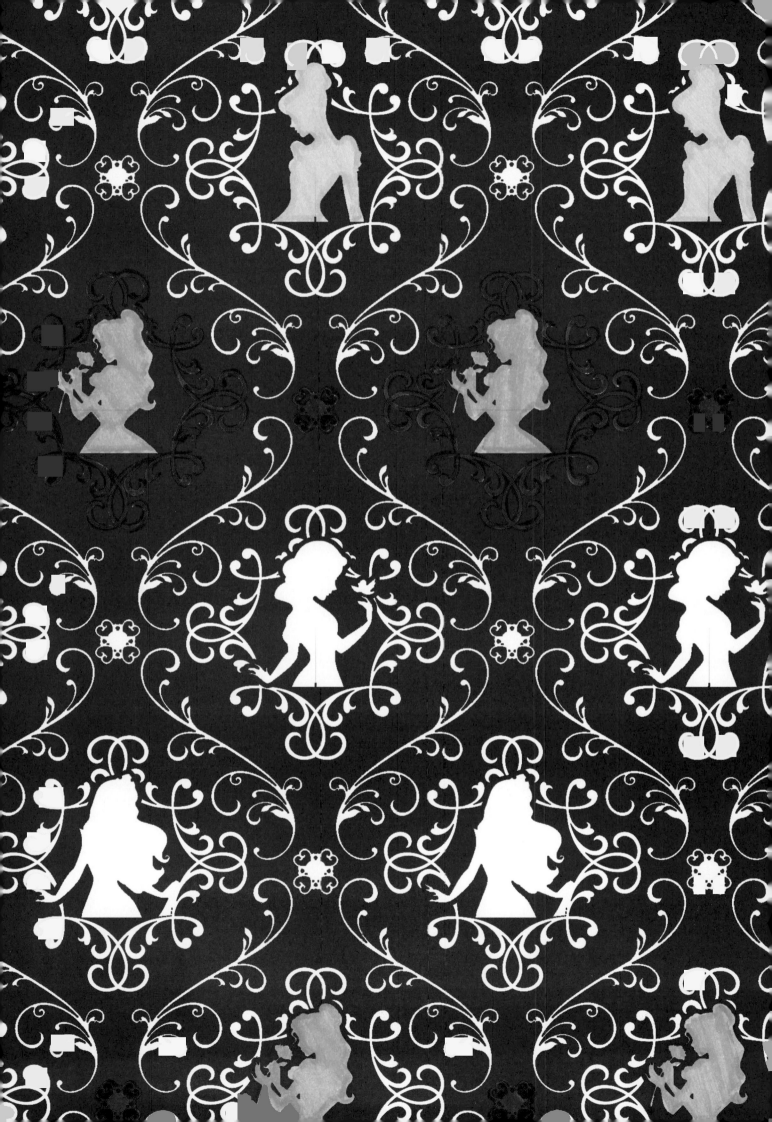

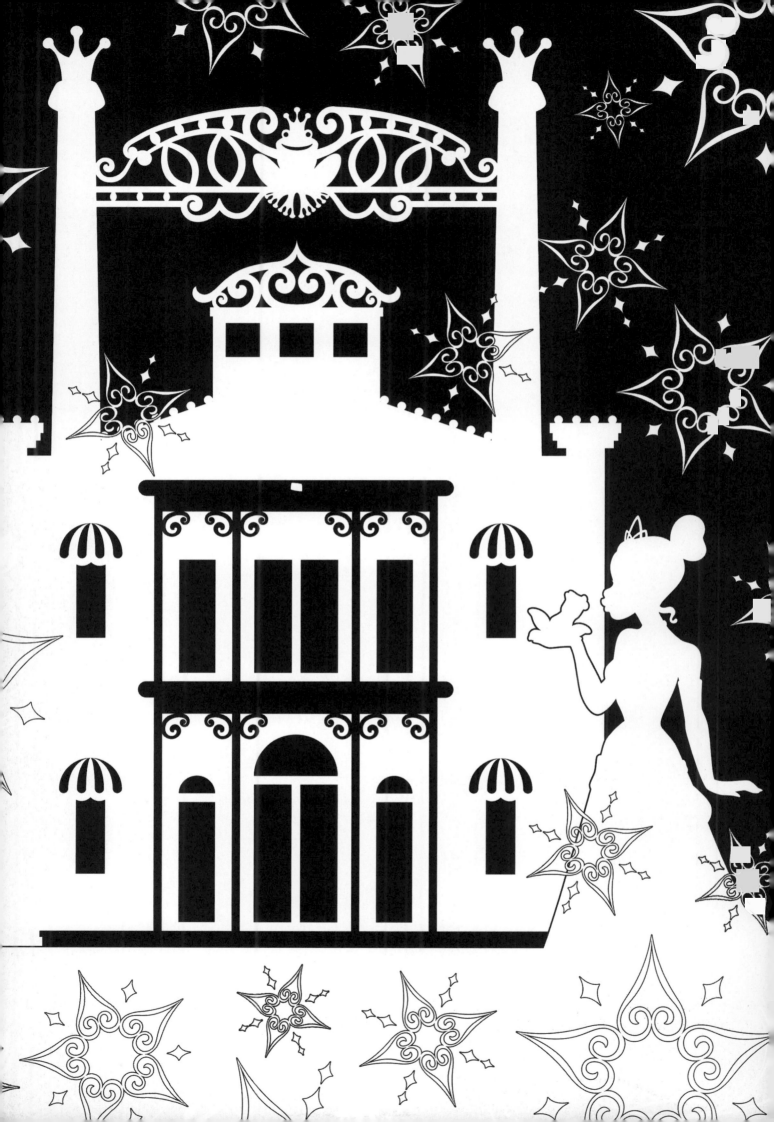

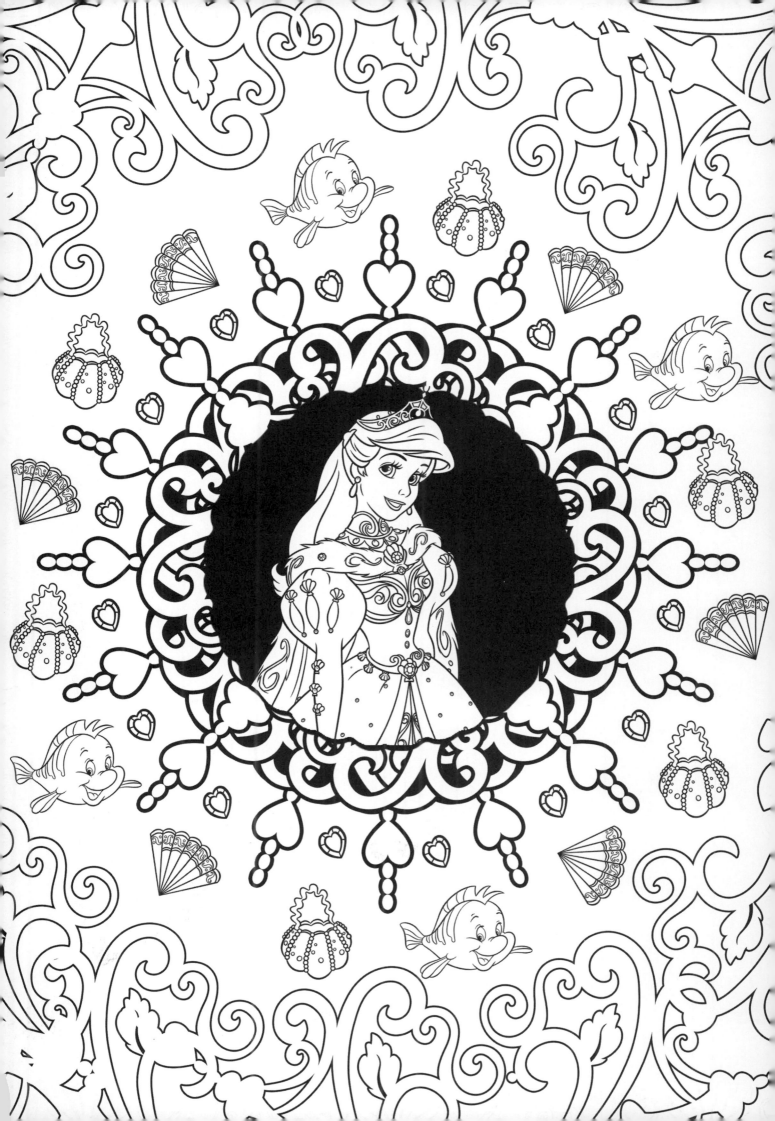

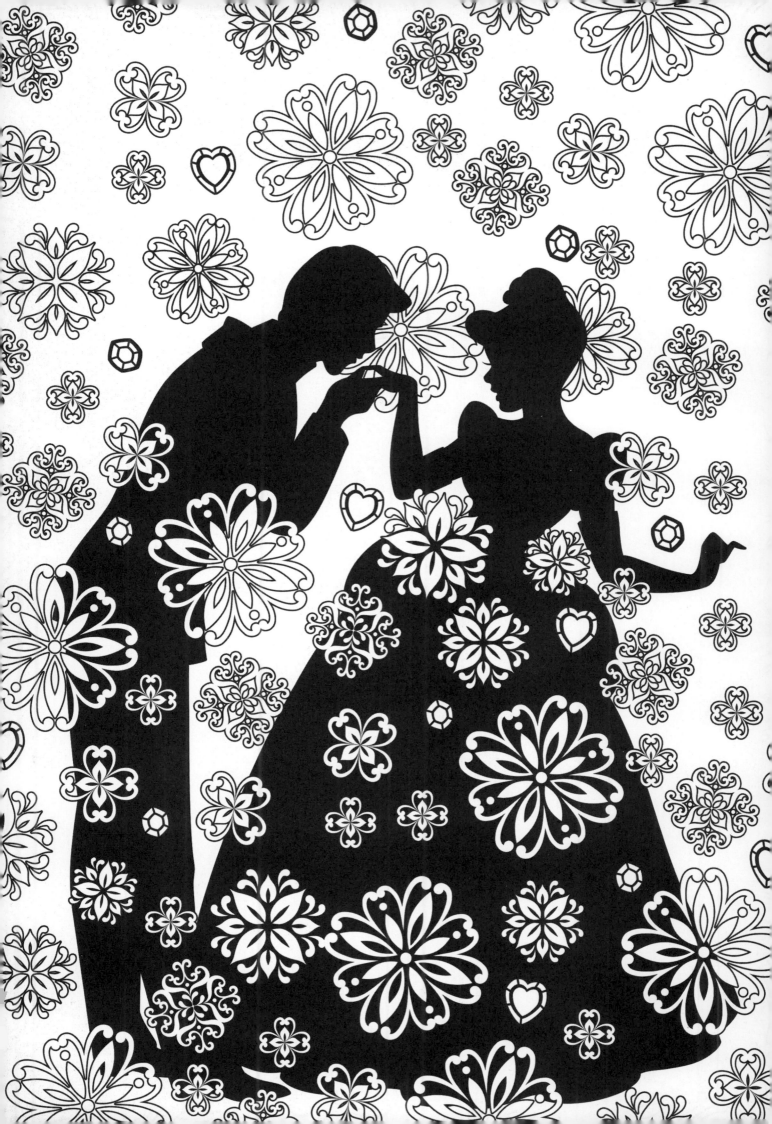

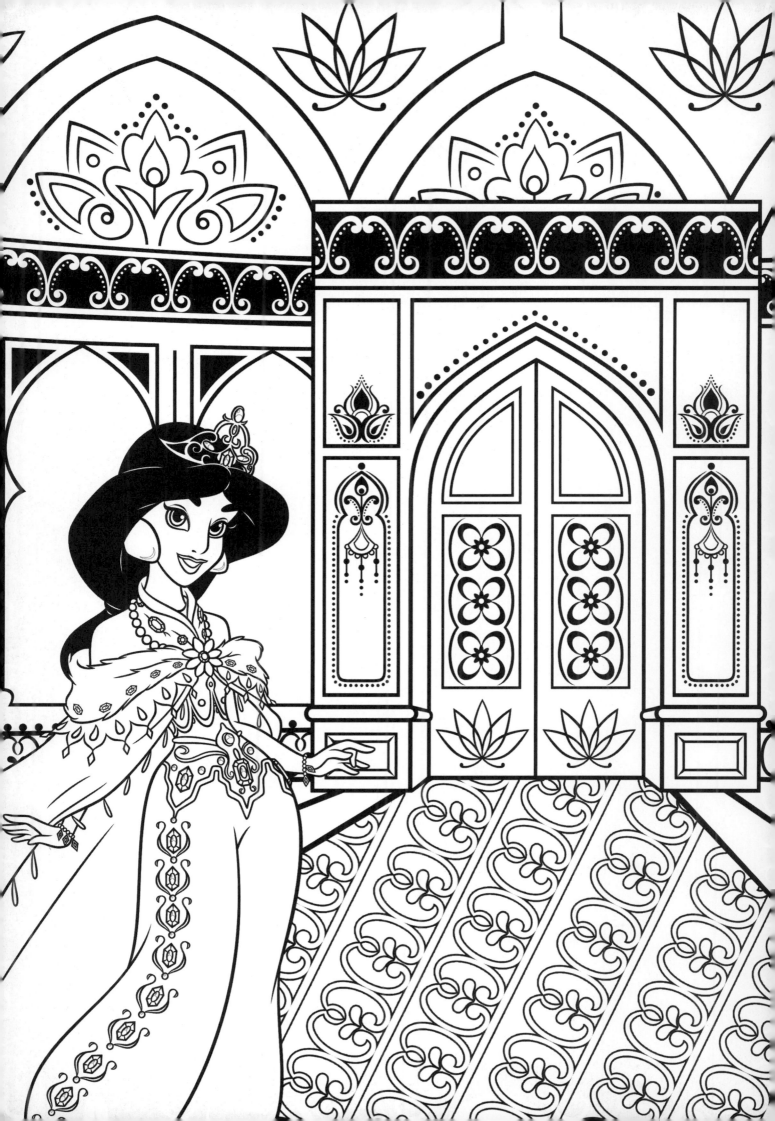

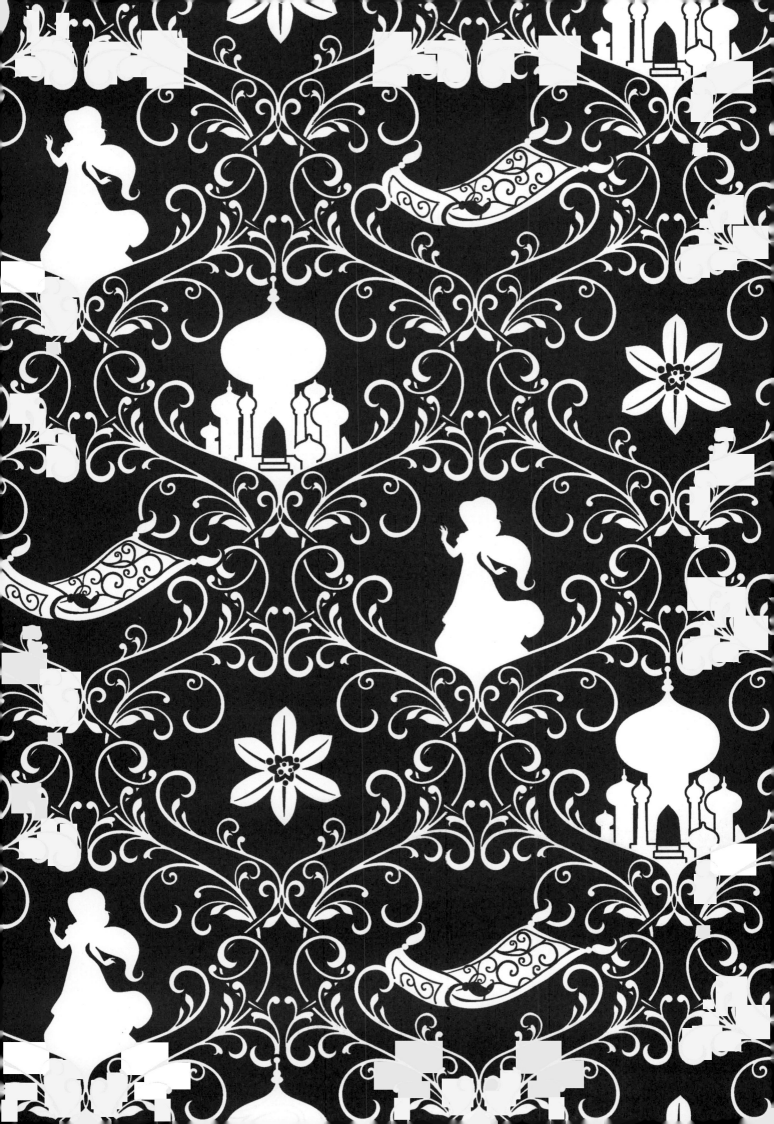

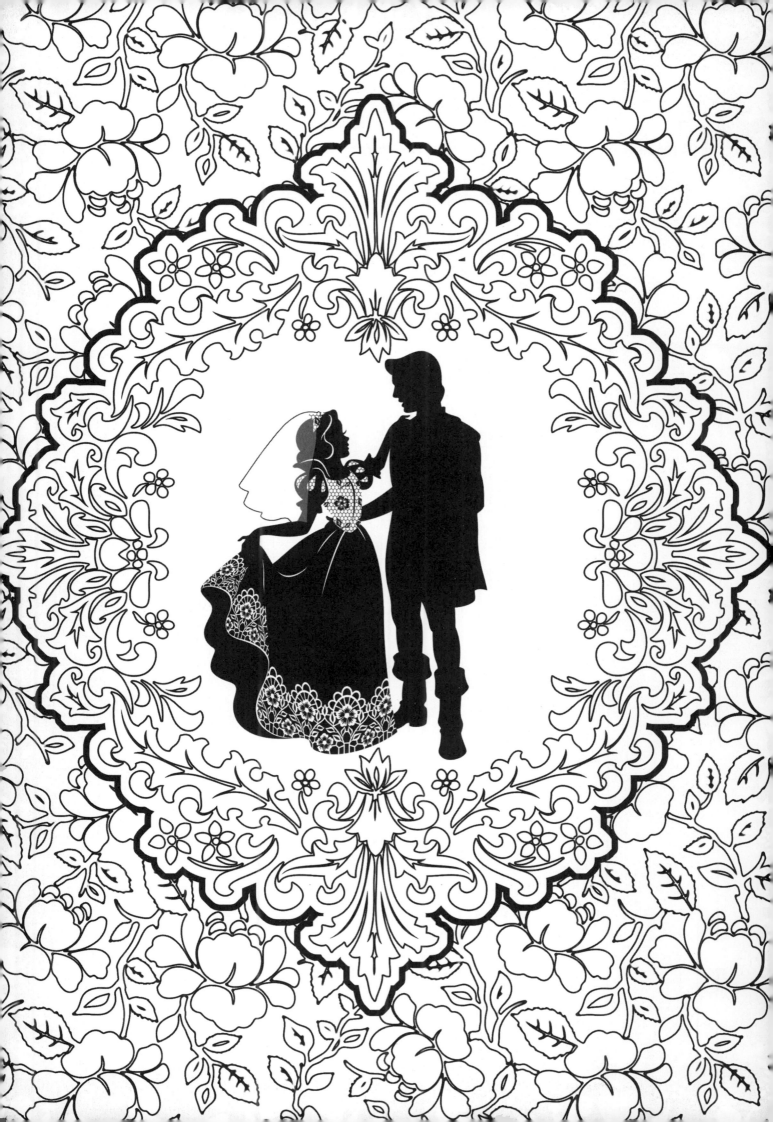

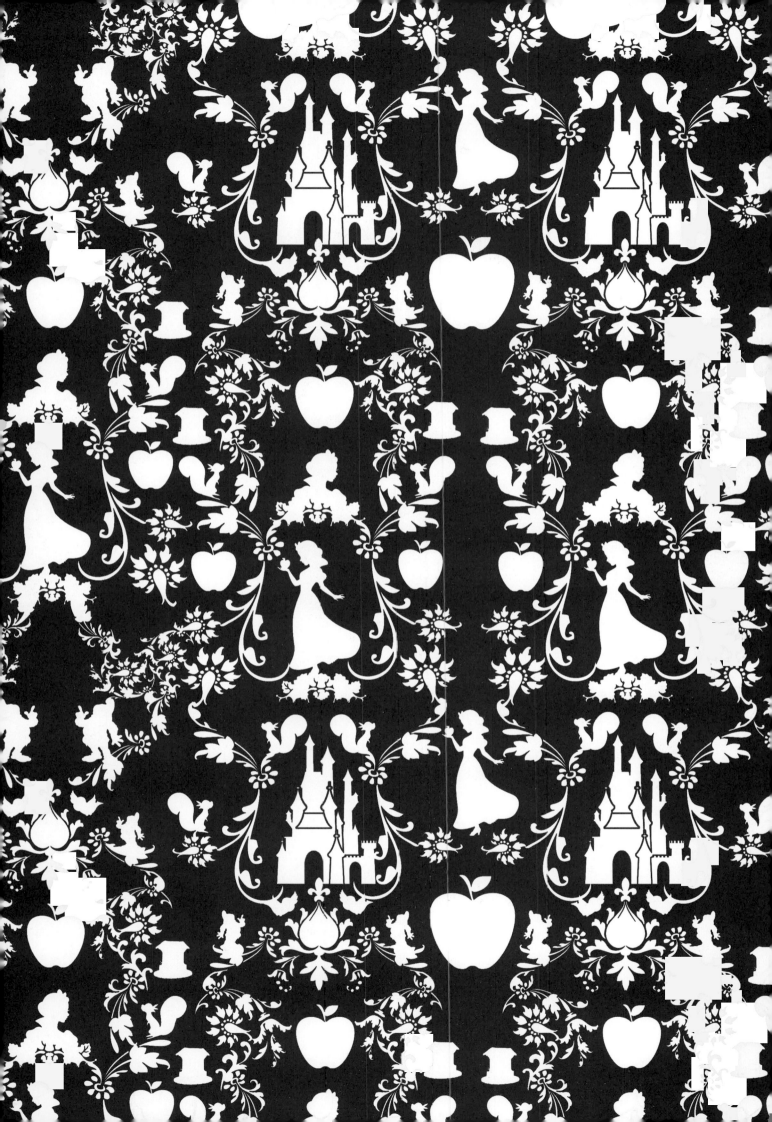

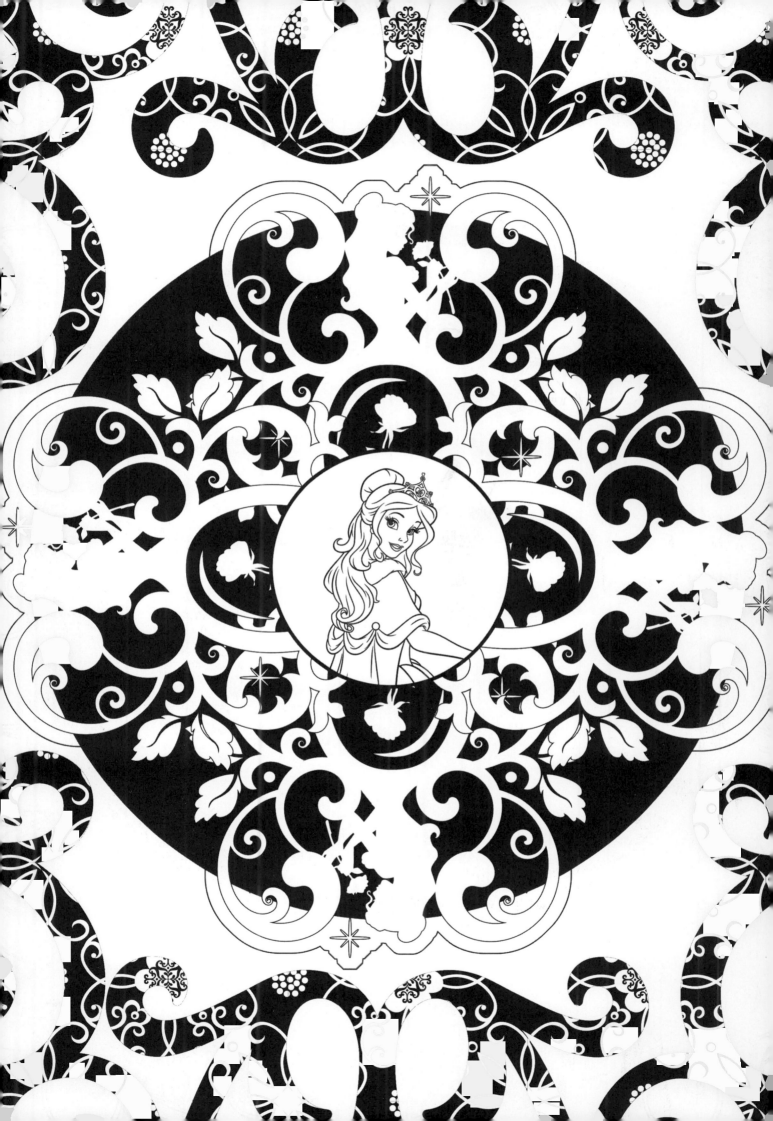

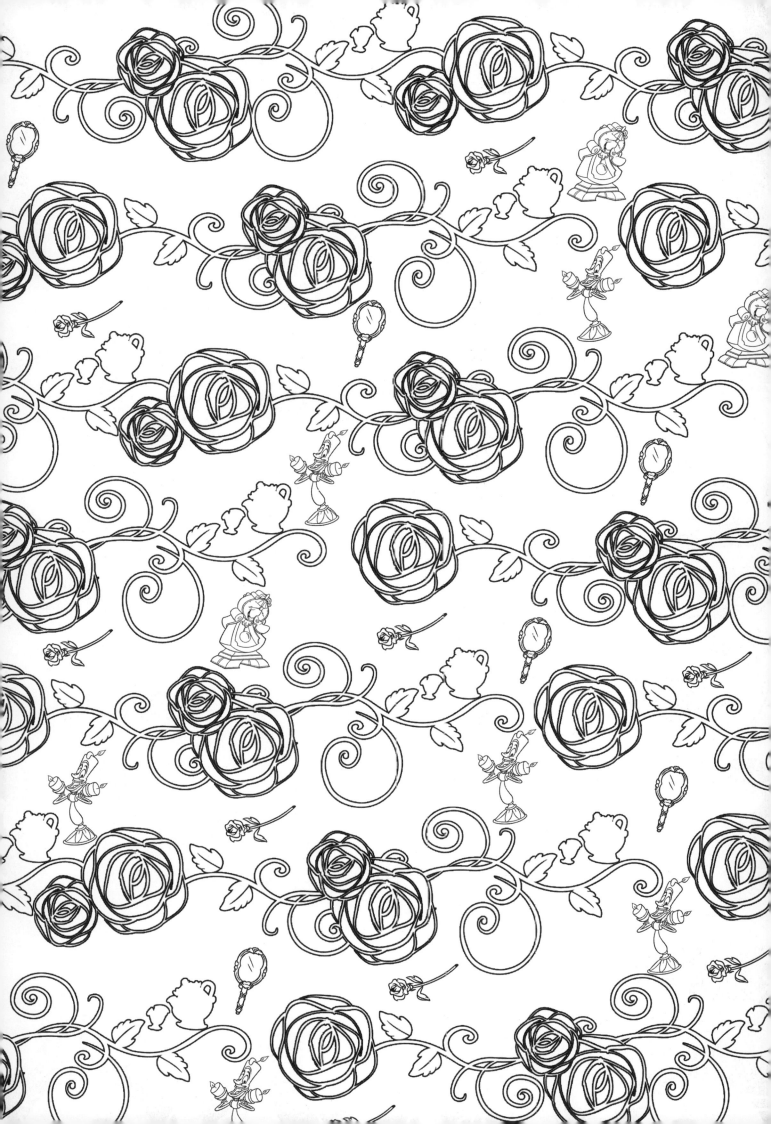

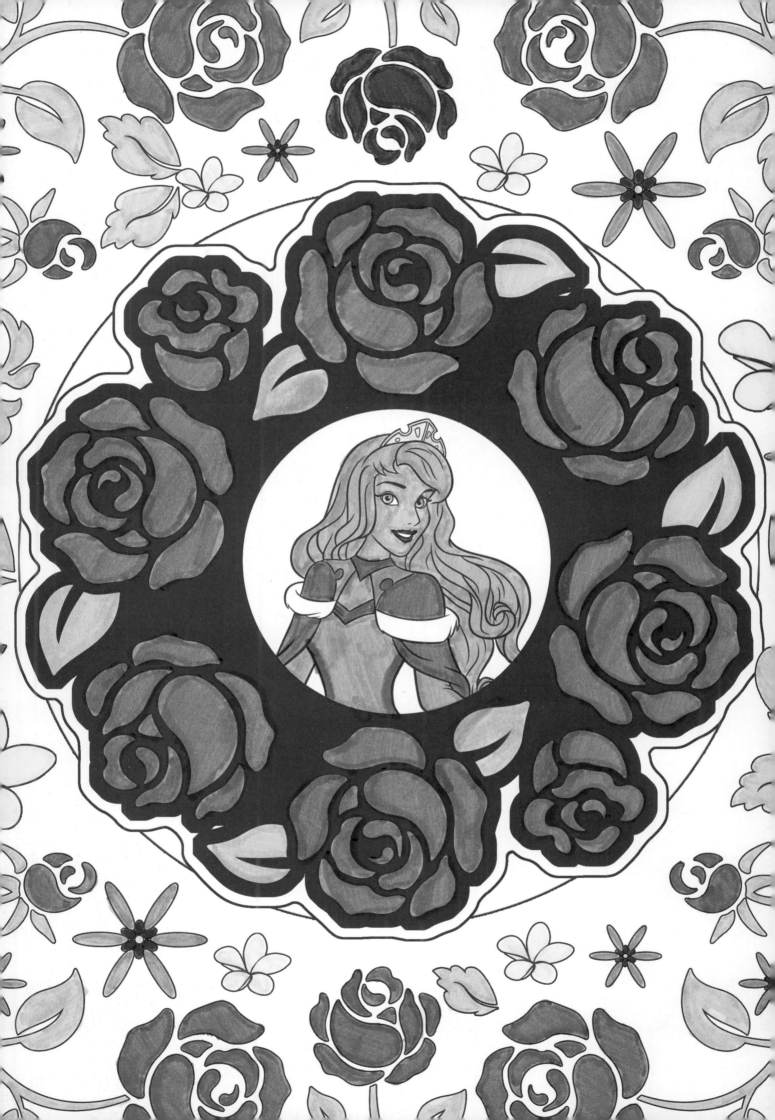

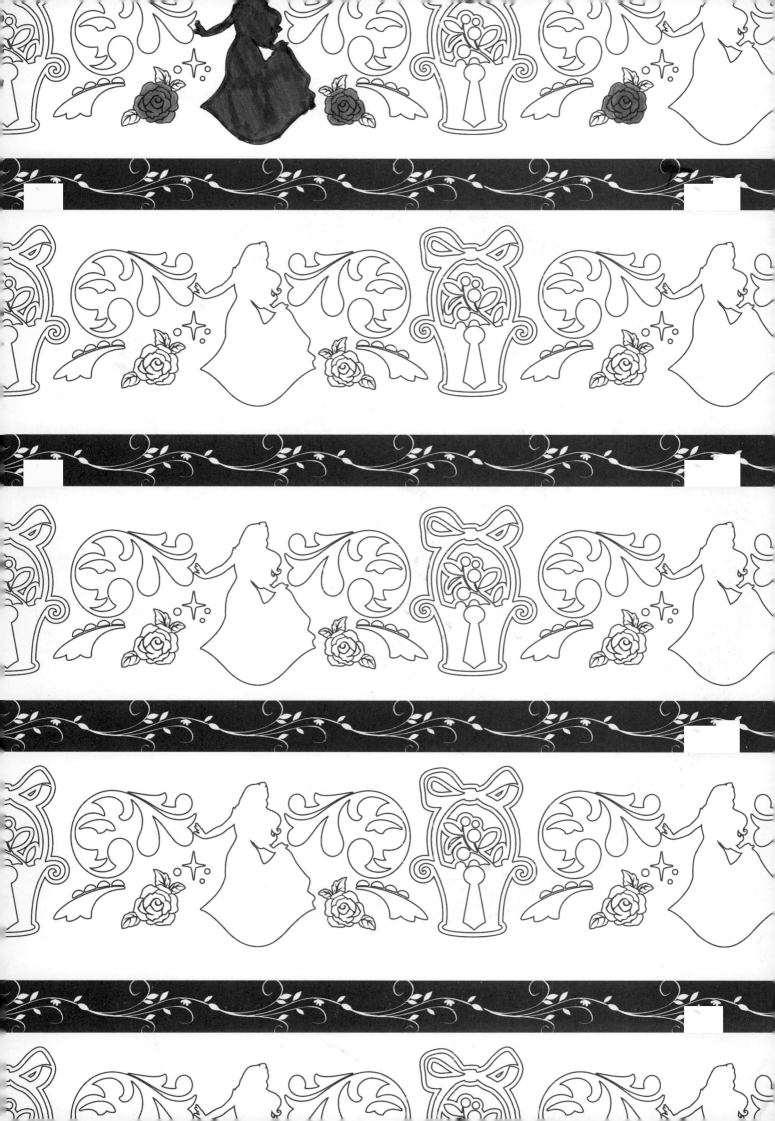

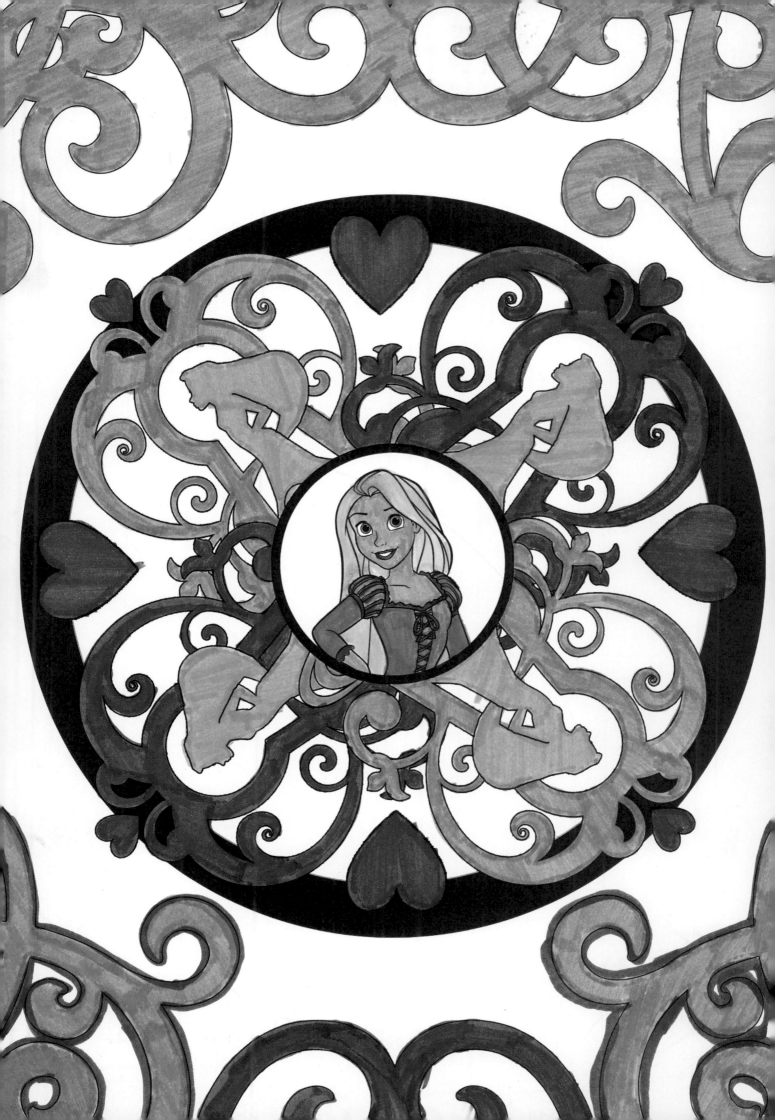

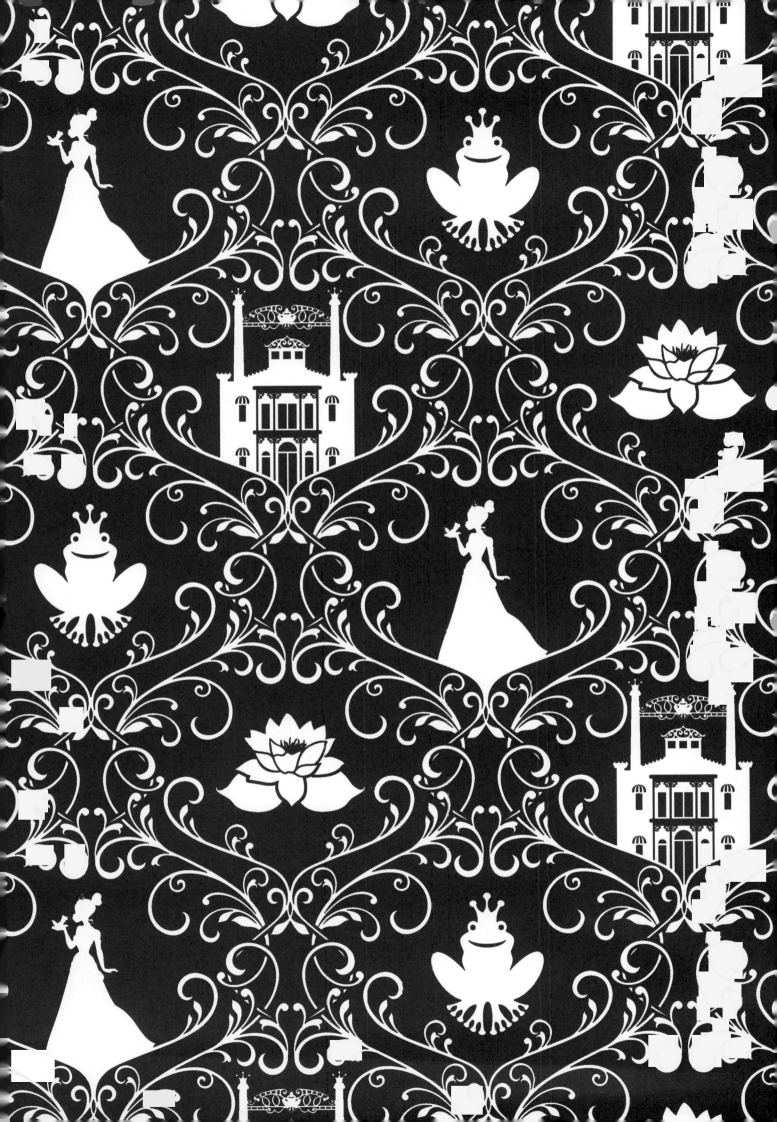

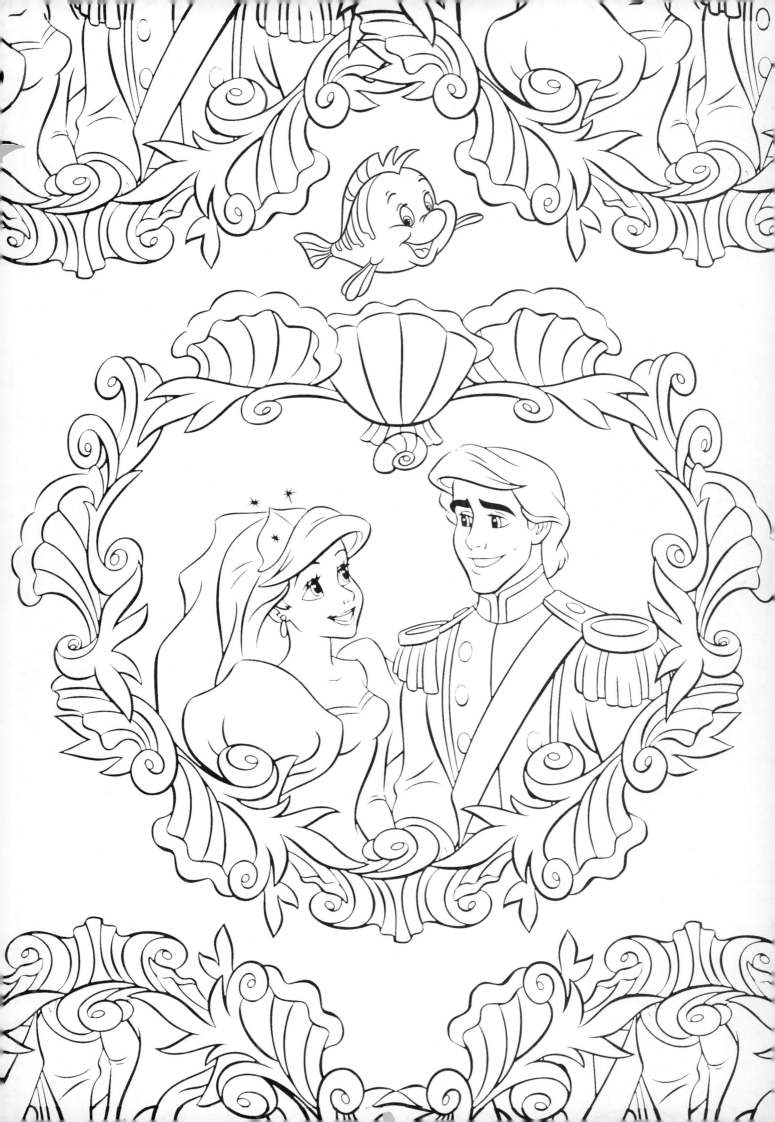

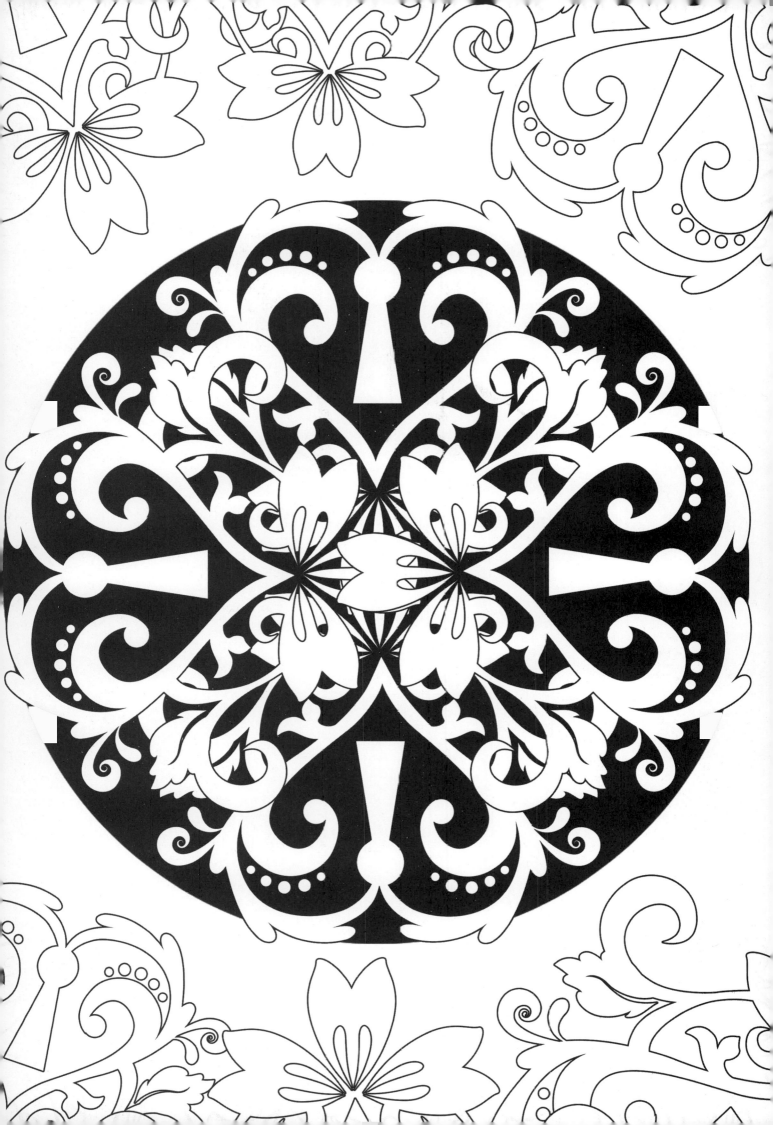

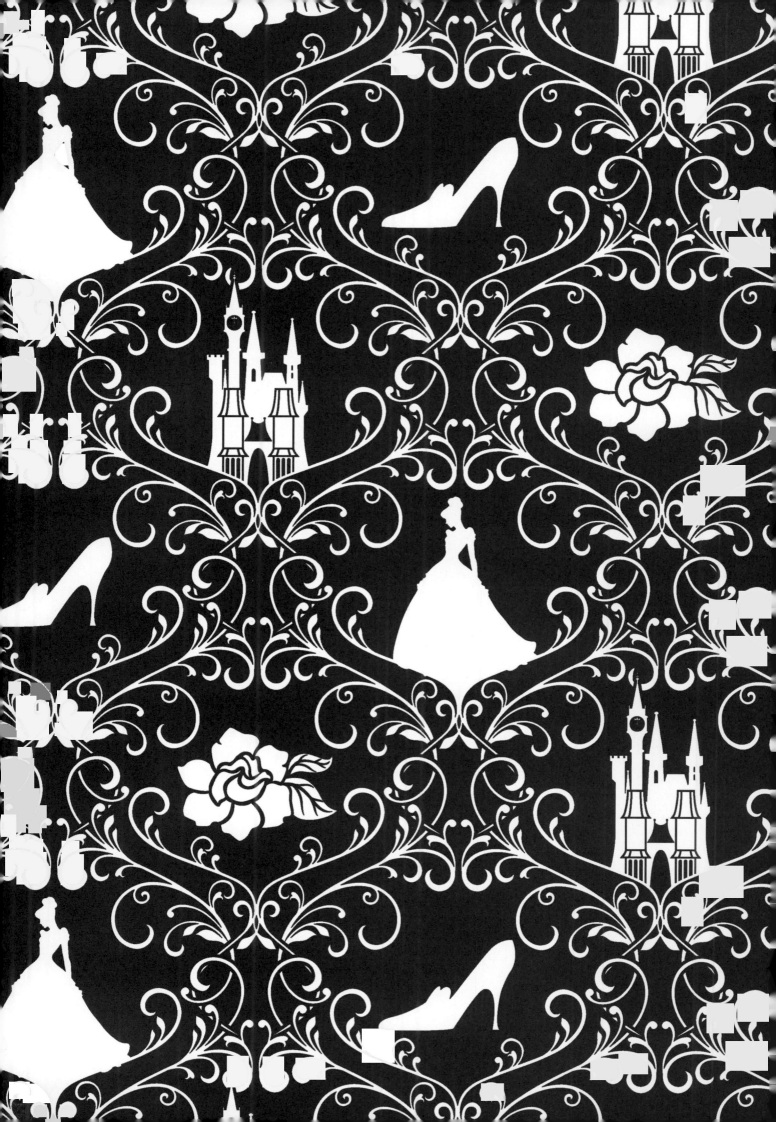

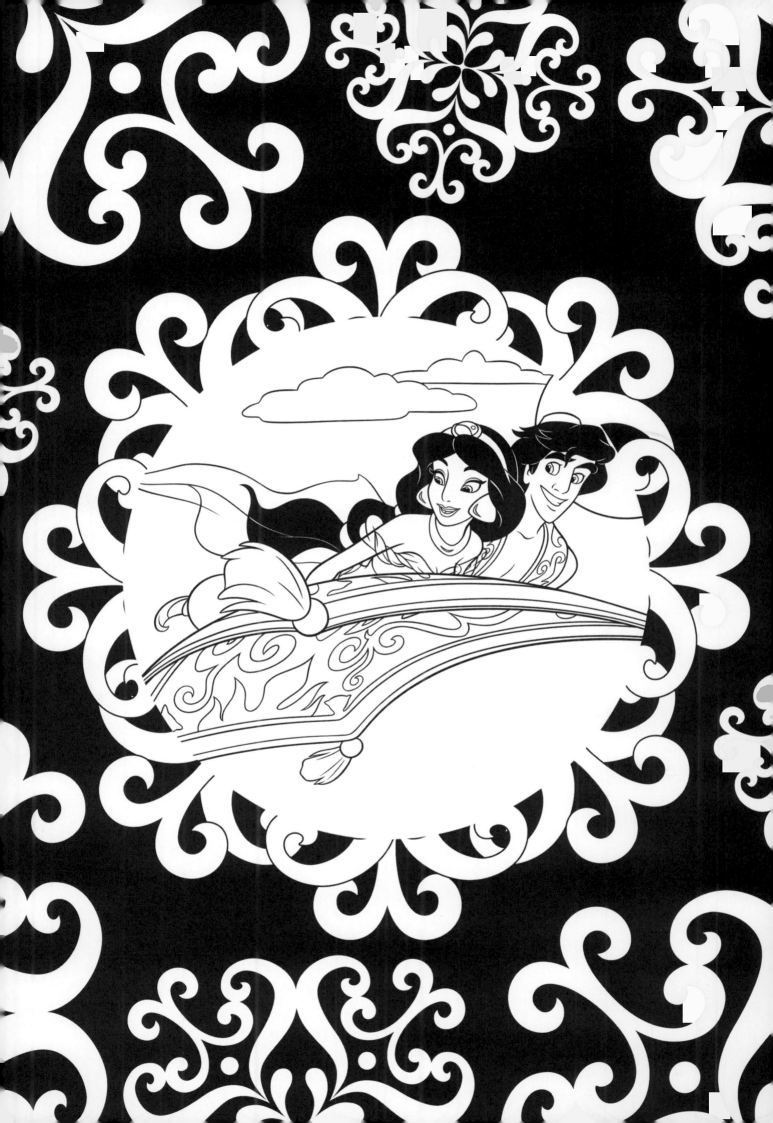

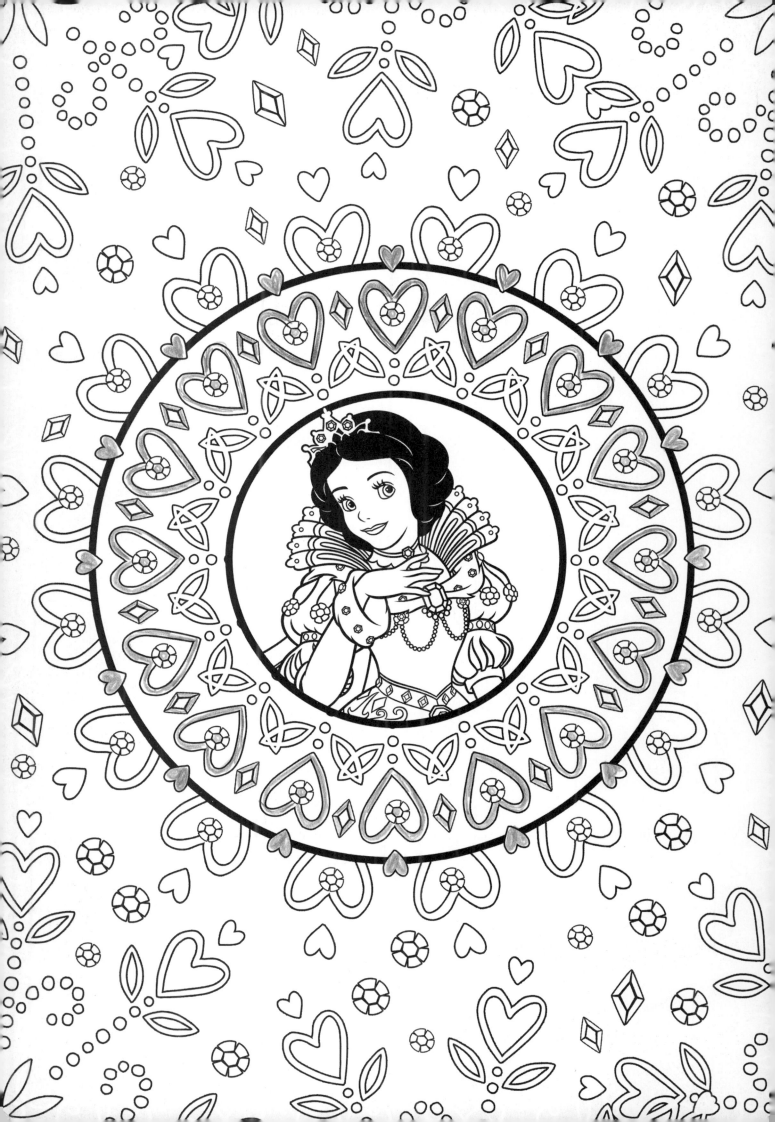

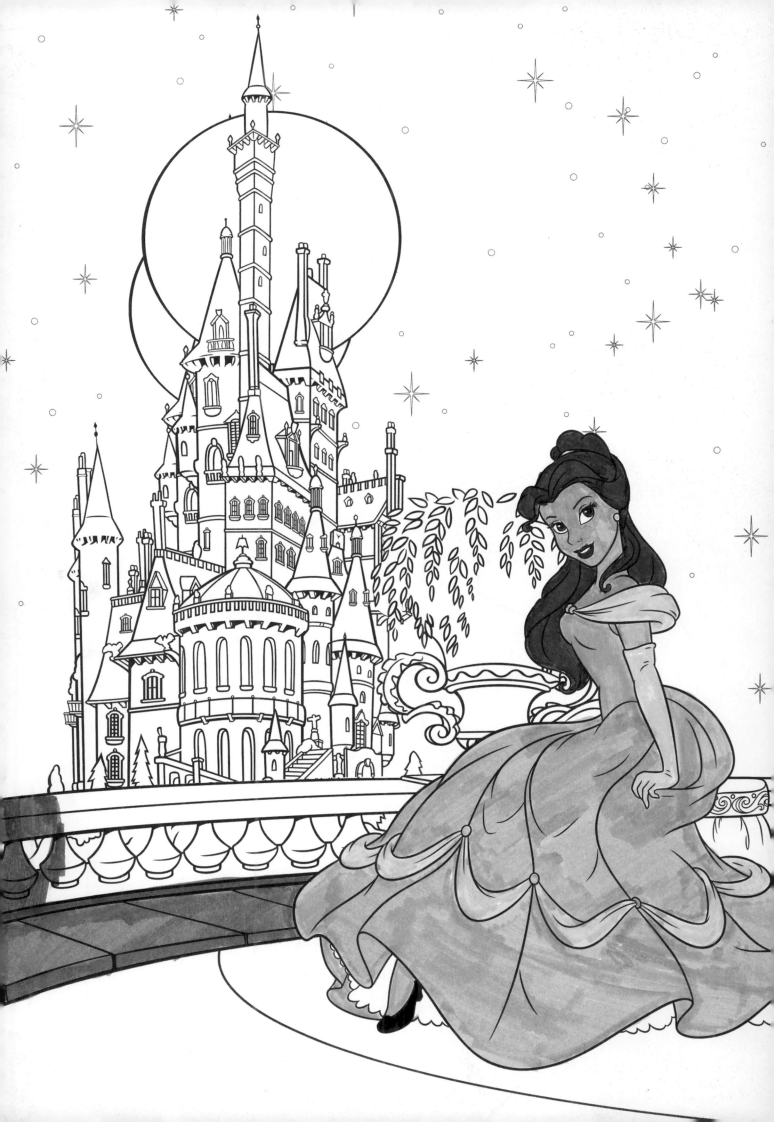

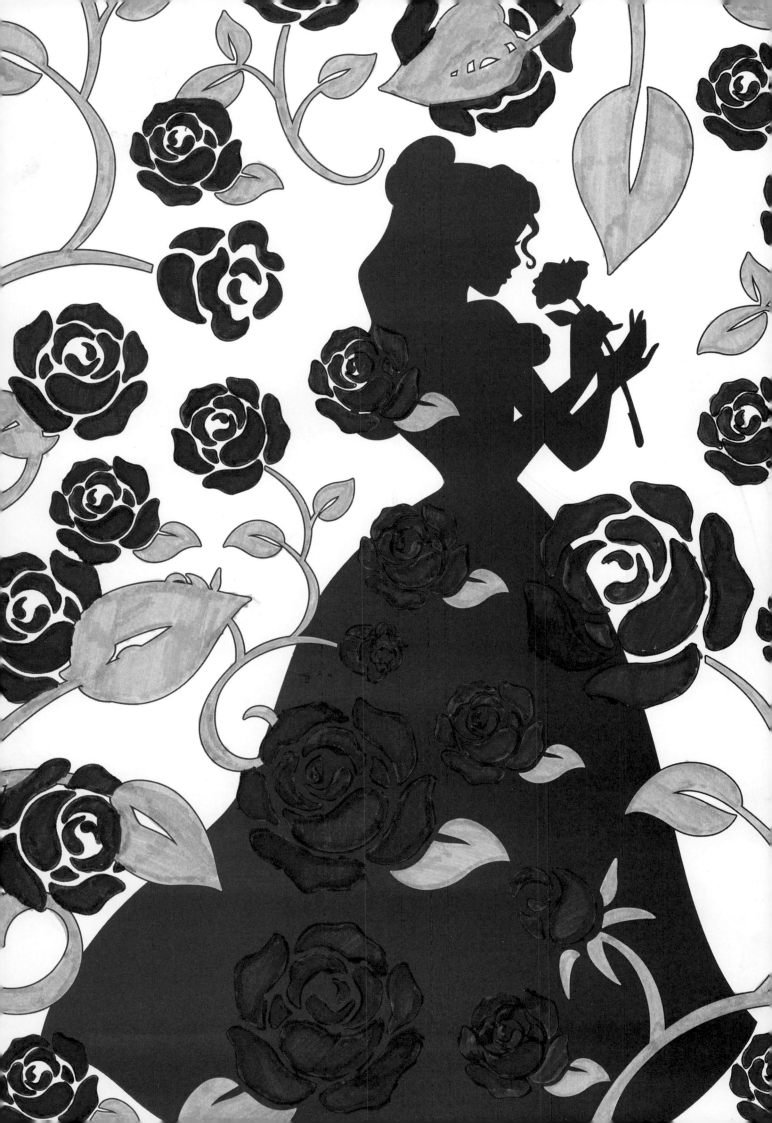

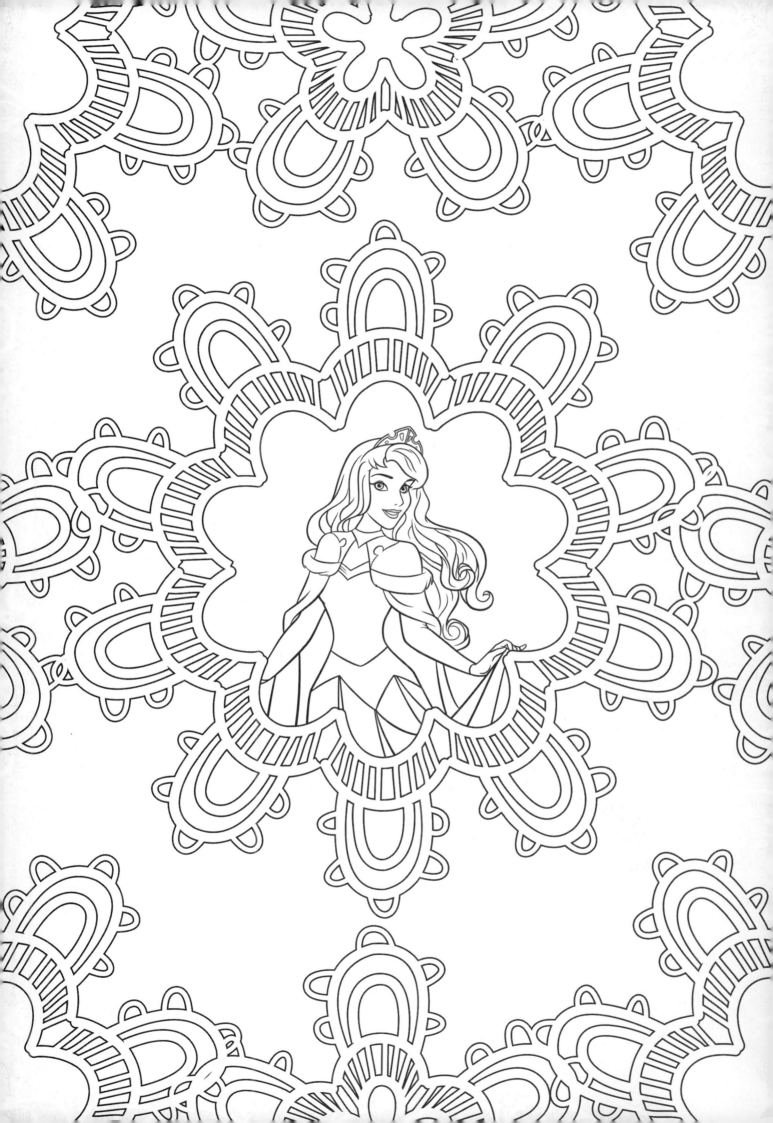

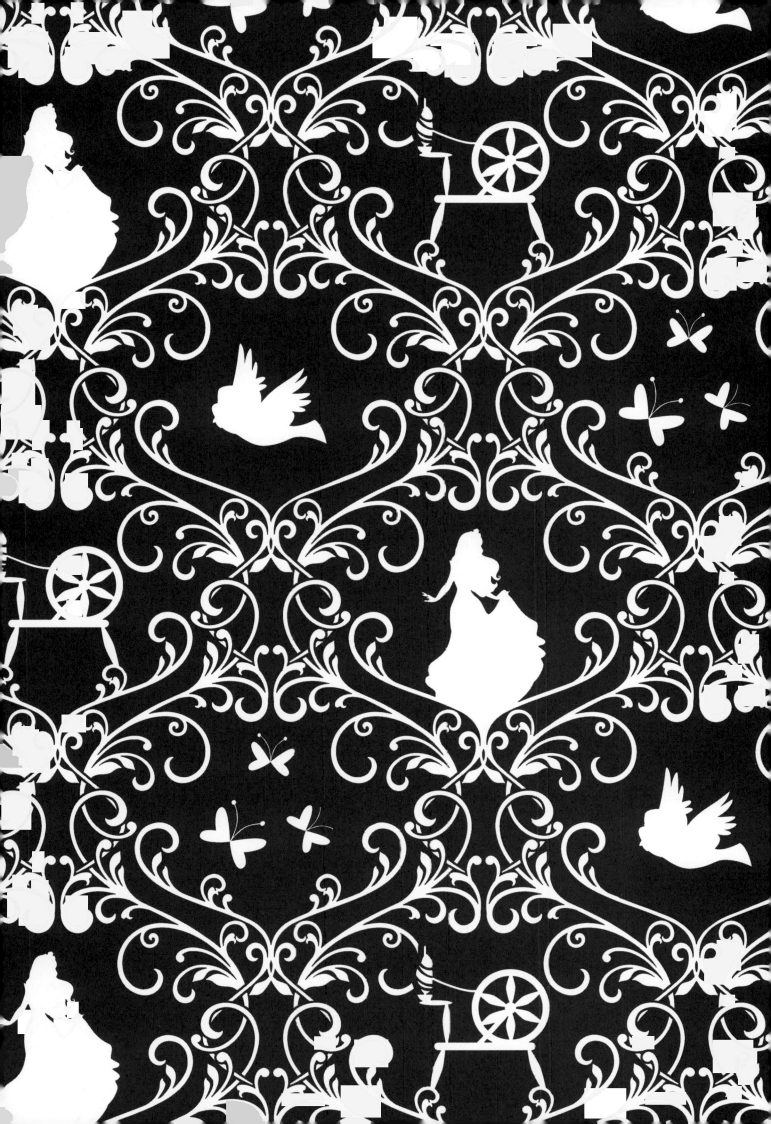

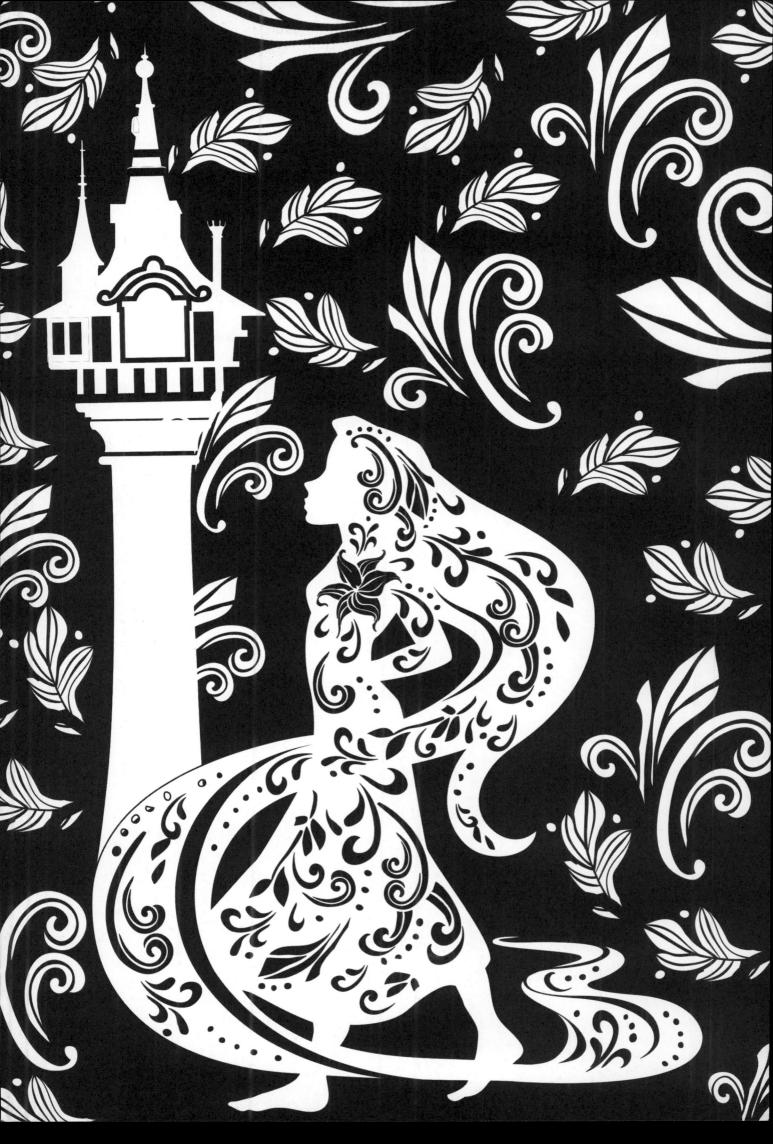

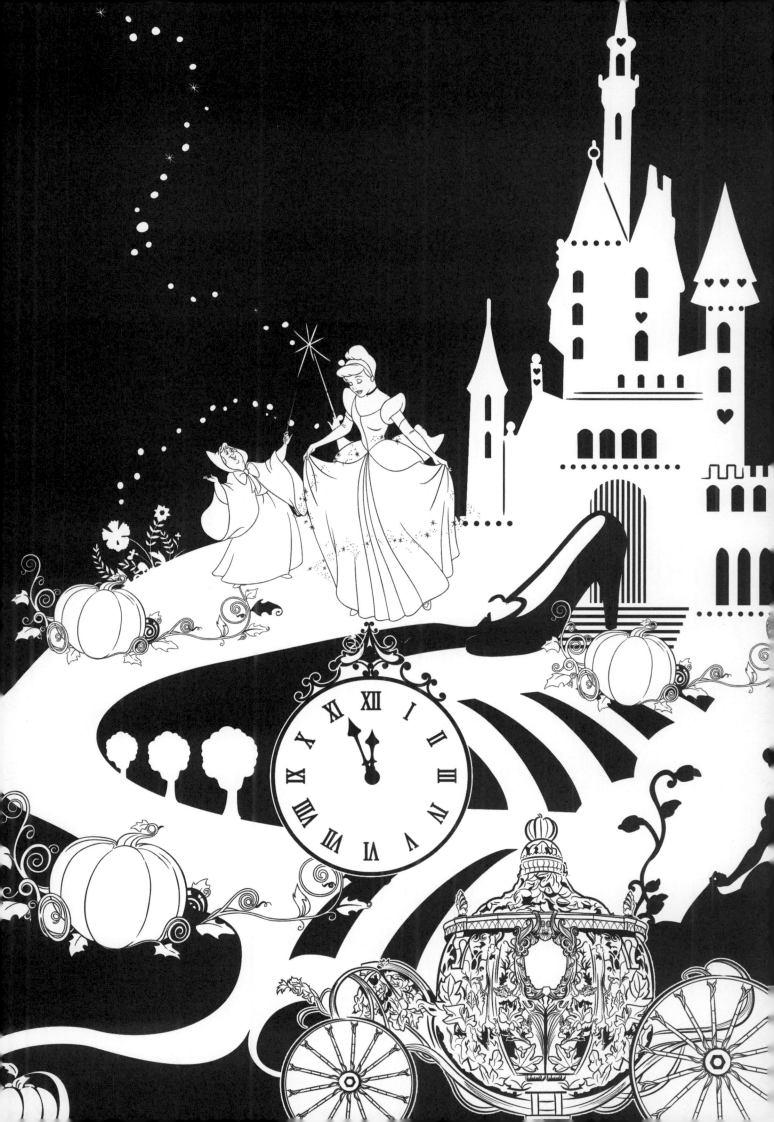

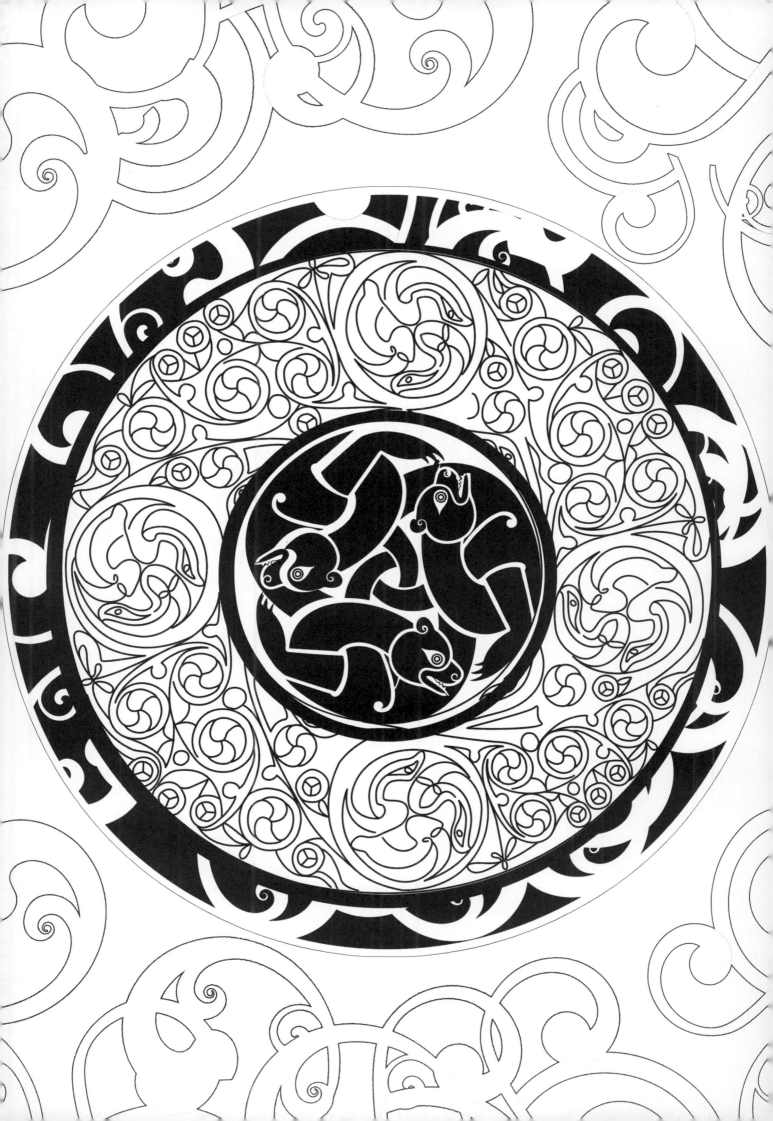

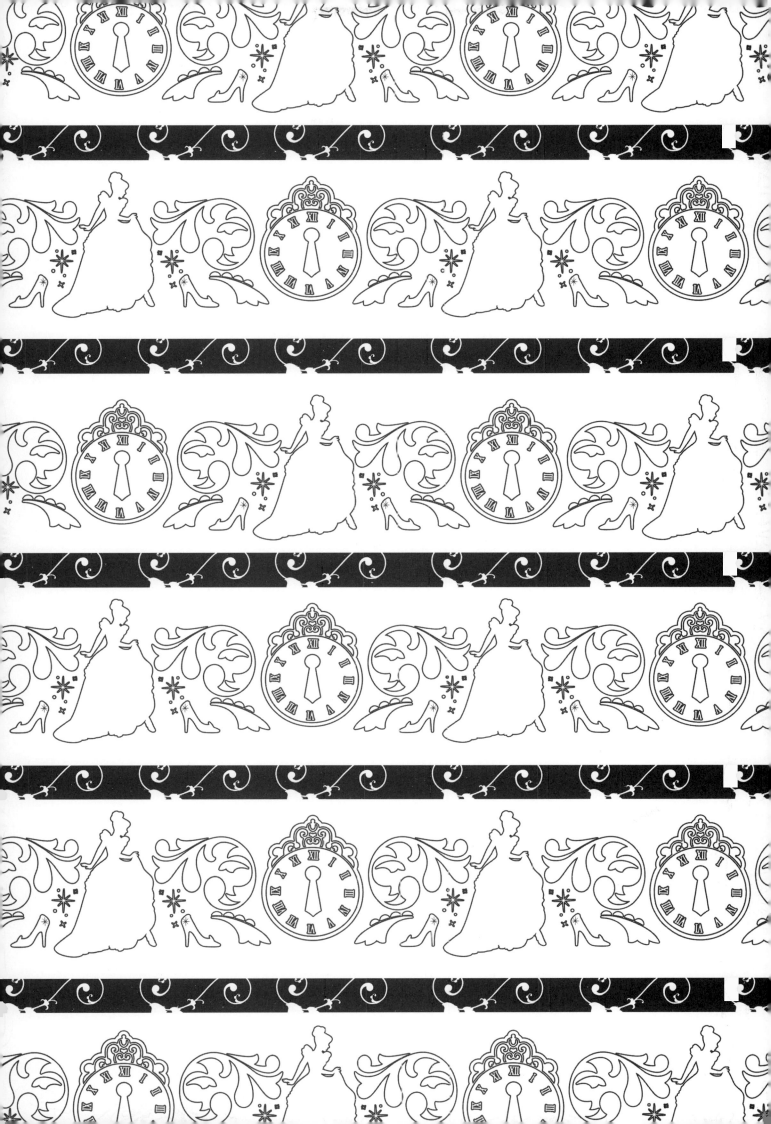

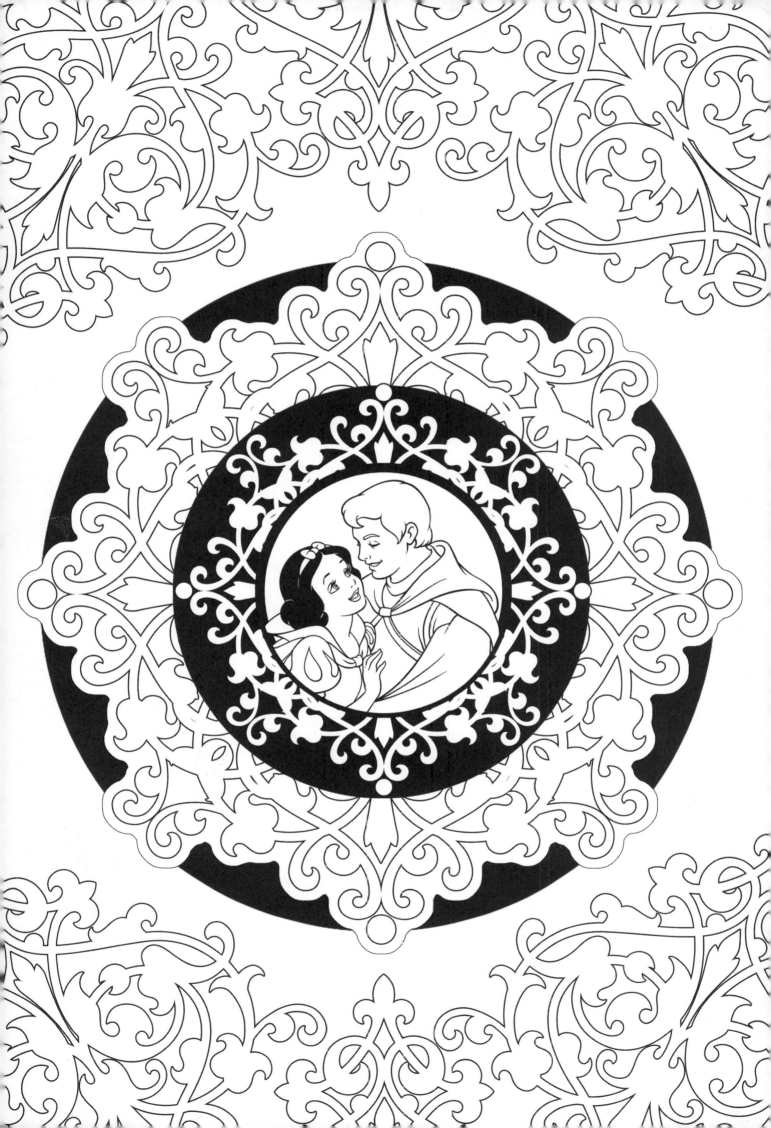